PARIS IN AUGUST

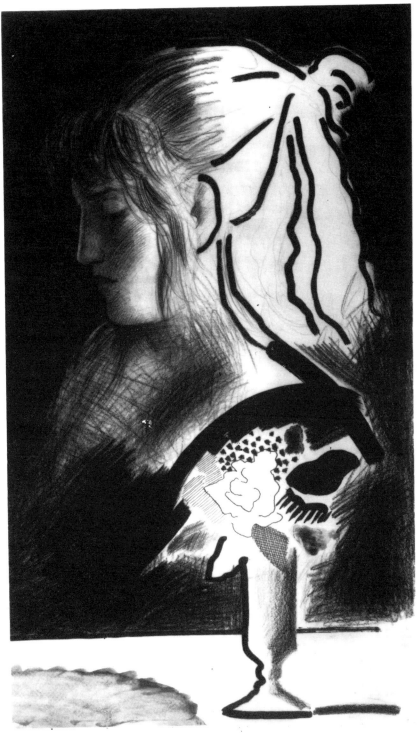

PLATE I

ADRIAN GEORGE

PARIS
IN AUGUST

Peter Owen
London & Chester Springs

FROM
A to B

PETER OWEN PUBLISHERS
73 Kenway Road London SW5 ORE
Peter Owen books are distributed in the USA by
Dufour Editions Inc. Chester Springs PA 19425–0449

First published in Great Britain 1994
Text and illustrations © Adrian George 1994

ISBN 0–7206–0937–2
A catalogue record for this book is available
from the British Library

Printed and made in Great Britain by
St Edmundsbury Press Bury St Edmunds Suffolk

Preface

I have known Paris through every season, in every month. The August days are distinct.

Much of Paris closes down. Parisians take their holidays; the streets, away from the Grands Boulevards and tourist sites, empty.

A sunlit, echoing, ghostly town.

The words of the book are the events and musings from my journal of August 1993.

The pictures are portraits of friends, people I know, paintings from my studio and pages from sketchbooks. They are not necessarily from particular days, but sometimes they connect.

I am accursed or blessed with restlessness and curiosity, which leads to much travelling, but I am always pleased to return to the 6th arrondissement.

However delightful or disappointing the day, it is always enchanting and consoling to walk these streets. Through this stone, lead and iron landscape, melancholy but beautiful, traced with the history of wars and revolutions and the extraordinary art, ideas and legends of the people who have lived here.

Everyone of course, has their own Paris; this is a portion of mine.

Reading it now I see how the moods of the days change, as do the pictures with their various methods and mediums. This book is a remnant of the larger, yellowing medium, time.

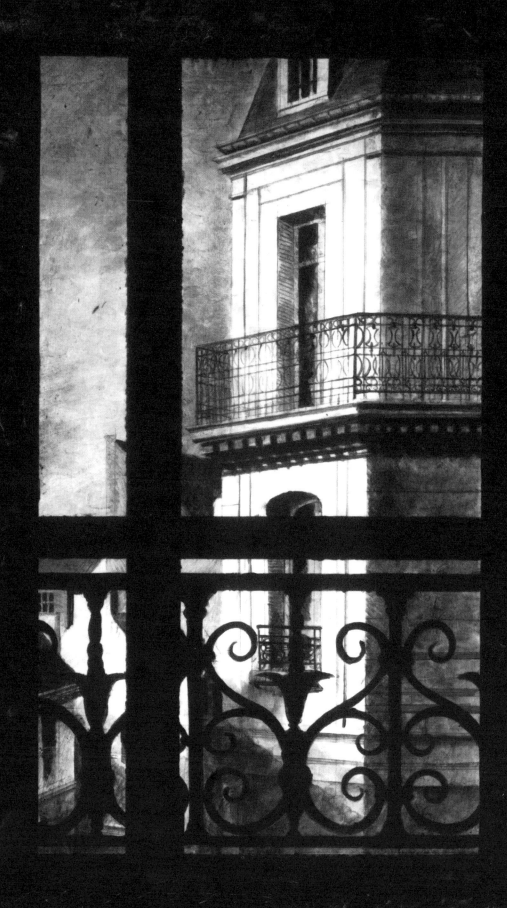

Sunday, 1 August

Silence.

From my window, the rue Dauphine tapers like memory. The sun falls softly, baking walls, drying tearful grey to cream. Fine cracks in paintwork, floury like the dusty crust of bread.

Paris, with its filigreed lace iron balconies, is once again the most southerly of northern cities.

August is a kind month.

Paris is emptied, Parisians pack their cars with their wives, children, grandparents, dogs and cosmetics and drive to the sea or the mountains or the great rich countryside.

History repeats itself as farce.

PLATE III

The population of Paris streams south as if from a German advance in the 1940s, only for the descendants to fight each other on the beaches for sunbathing room, and lie there side by side, like the dead on a battlefield.

The city is stripped of its middle-class, leaving behind the very poor and the very rich. Some shops remain open, some restaurants, there is always something to eat in a city that has an eating place for every twelve of its population; there are twenty-five bars, restaurants and delicatessens in the rue Dauphine alone.

The escapees also leave behind tourists, policemen, *clochards*, pigeons and, of course, lovers.

From beyond the cubist landscape of blue-grey lead roof-tops, terracotta chimney-pots and the skeletal assemblages of television aerials, comes the summoning peal of the bells of Notre-Dame.

PLATE IV

8

PLATE V

PLATE VI

It is Sunday and one must make an act of faith. Mine is to go to the bookstalls on the banks of the river Seine.

Alone in the street, a black man in green overalls sulkily swishes his broom in the water that runs in the gutter; like a conjuror he makes pigeons explode to the sky.

The city of Paris began some 3,000 years ago, on the islands in the river Seine.

The best-appointed river in the world, romantic architecture and bridges, riverboats, working barges with plangent sirens. On the quays people fish, sunbathe, play music, and dance; there are gay dogs and dogged gays.

Lining the parapets and pavements above the river bank are the *bouquinistes*, second-hand booksellers, who have been there as long as printing.

The city is divided by the river. The Right Bank is serious, political and businesslike, the Left Bank is bohemian, bookish and rebellious.

There are booksellers on either side, but the Right Bank is another country; they cage geese there.

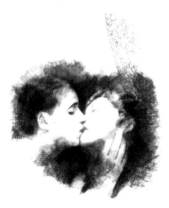

PLATE VII

My pleasure was to walk from the Pont-Neuf (the oldest bridge in Paris, despite its name) which is at the bottom of the rue Dauphine, down along by Notre-Dame, to the Tour d'Argent restaurant.

As a private library will reveal the interests or pretensions of its owner, so one or other of the green steel boxes will open

to show the history and the treasures and the detritus of the Left Bank mind.

Books, dusty and jumbled, some neat in rows, precious in glass cases or sealed in plastic, not to be handled without permission.

A *flâneur* strolling under the pointillist shadows cast by the plane trees, might feel as if this was Sunday afternoon on Seurat's *La Grande Jatte*. One finds odd juxtapositions, enough chance meetings for Lautréamont.

The Marquis de Sade, who would have been pleased, laid next to Joan of Arc, who would not. Books on the varied activities of Jean Cocteau, old copies of *Vogue* with drawings by Bébé Bérard, early editions of Colette from when Willy was her master. A thousand books for cooks, a hundred things to do with a chicken. Serious monographs on Abstract Expressionists, Expressionist monographs on serious Abstractionists. Another play by Jean Genet, a study on the choice of voice for James Joyce. Castiglione's book of Renaissance etiquette for the court of Urbino and ghastly tales of concierge murders. Napoleon's victories and defeats on the battlefield and in the bedroom. The exotic travel writing of Pierre Loti, who is much neglected now, but inspired Gauguin, Proust and Puccini, who are also there.

The walk is punctuated by bridges, under which Henry Miller practised what he preached in the Olympia Press.

Where the Pont St-Michel crosses the river, tourists cluster dressed in ubiquitous anoraks, coloured leather scrotum pouches to hold their money, and inflatable trainers. They stare at books and catalogues of colonial memoires and exhibitions, illustrated with photographs of their more distinctive and more elegantly dressed ancestors.

The secret society of book dealers whisper and trade in treatises on black magic, in front of the great anchored silhouette of Notre-Dame.

There are posters of the icons, James Dean, Marilyn, the Madonnas, old and new, and Serge Gainsbourg, a heroic example of the Left Bank liver and life.

There are old copies of *Signal*, a Nazi magazine published during the Occupation for the German armed forces.

Collections of old records, comic books, English paperbacks abandoned in hotel rooms. Music hall song sheets, they never forget Mistinguette, and textbooks from the Sorbonne. Magazines of plump, permed beauties from the music hall and the photographer's studio, doing the things that Paris is celebrated for, inside faded covers with titles like *Paris Plaisirs*. These are all Paris pleasures.

Monday, 2 August

Framed in a window across the street, two disembodied hands delicately pick out Satie's *Gymnopédies* on a piano. The graceful exercises of young spartans are disrupted by Madame Concierge screaming.

Tony Peto and Marie Mercier arrive. Tony Peto brings a hatbox that looks like a drum. They make hats, they have several shops in Paris and one soon to open in Tokyo. Tony Peto has asked their artist friends to decorate hatboxes for an exhibi-

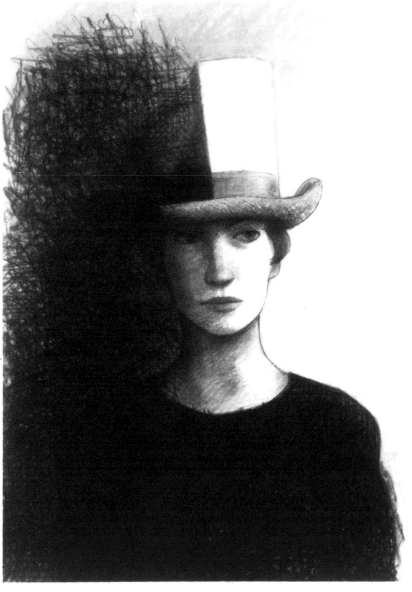

PLATE VIII

tion. Marie Mercier a designer of hats, wild and wondrous crea-
tions. She puts on a little cubist number from her last show for
me to draw.

Marie Mercier's shows are a delight, not the desperate
anxious catwalks of the grand couturiers, but charming theatrical
events with plots, scenery and real music. Marie is auburn-haired,
chic and giggly, at one time the 'Kodak girl' of France, in many
ways the embodiment of the 6th arrondissement.

She has had several husbands. Tony Peto, the latest, an
Englishman, says, 'She has had so many she can't always re-
member their names.' She can remember wearing a red dress
when she was married in Taiwan. She has been a journalist: 'Of
the Left, what is left for the Left?' A speech writer for Jack
Lang, minister of culture in the last Socialist government, staunch
defender of French culture but with an odd appetite for some
things American. He once organized a graffiti exhibition at the
Pompidou Centre, as if Paris has not suffered enough.

Marie sat with the straight back of the dancer she once
was, and she still performs with a circus troupe.

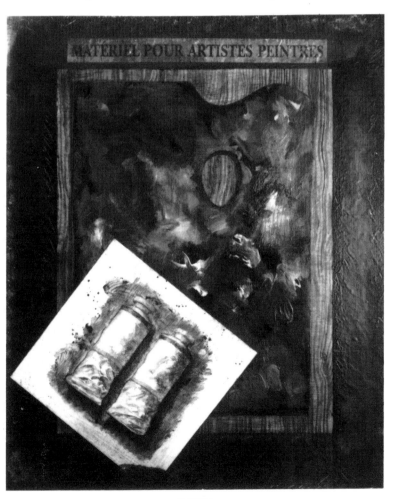

PLATE IX

Tuesday, 3 August

It is very hot in the empty quarter.

Dog days, dogs are all around; there is an animal scent to the streets. Perhaps the cleaners are on holiday with their 'pooper-scooper' motor bikes, perhaps the Mayor himself is away. He usually tries to prove his fitness to accede to the Presidency by his mastery of this old and crumbling city.

Yet it is beautiful, one can see the architectural follies, the intricate intimacies of the buildings, which are signed and dated with pride by their creators. There are mysterious de Chirico shadows and vanishing points, culs-de-sac.

In the rue Jacob a man is pissing behind a builders' skip; there are not enough *pissoirs*. A *clochard* slumped unconscious in a doorway, a rivulet runs to the road. A bitch urinates decorously into the gutter, her owner puffed with pride.

Paris dogs, there are fewer coiffured, perky poodles, there are big dogs, with their ears pinned up in a vain attempt to make them appear alert. They move like pantomime horses and wear scarves around their necks. Miniature dogs, ornamenting their owners' bosoms or peeking out of handbags. Once I dropped a lighter and reached for it under the table of Brasserie Lipp and saw twenty pairs of luminous hungry eyes staring at me, the little friends of the powerful, patiently waiting beneath the banquettes. It is better to be a dog than a cat in Paris. Cats have race memories, they remember the days of the Commune.

I need some materials to work with. Sennelier on the Quai Voltaire has been supplying the stuff of art for over one hundred years. I think of those who have bought there. The shop is dark. Varnished wood cabinets, brass-handled drawers with faded labels, easels, plaster casts of classical heads, articulated wooden lay figures gesture in the gloom, glass bottles of pure pigment, intense blues, scarlets, yellows, spectrums of paint in tubes and cans. Brushes in all sizes and substances, from silkiest sable, to brutish bristle. Fans of papers, creamy, rough, handmade, Japanese water colour, Bristol boards smooth and white as ice rinks, everything imaginable, in single sheets, in rolls or bound in albums, or wired in sketch-pads. Canvases already stretched or by the metre, tough enough for sailors, fine enough to dress young girls.

Through the glass shop door one can see the end of the Louvre across the river where the beautiful Velázquez *Infanta* is hanging carelessly but undisturbed, at the end of a long corridor.

The sunlight beams through the door like a ray from a Renaissance heaven; ochre with dancing dust, it illuminates posters of exhibitions now and gone, a notice board offering and pleading for studio space, artists' models and etchers' workshops. It lights on amber bottles of varnish, turpentine and linseed oils glowing the colour of old Sauterne.

A case of pastels, coloured dust, moulded by hand, tinted, many-hued sticks of soft chalk. These are for me, these handfuls of dust, as they were for Boucher, Degas and Pascin. To draw and stroke in colour, as tender and fragile as a living thing.

I pull out each drawer in the cabinet. The pastels are in rows like the keys of a piano. There are greys from misty cold dawn to midnight, through those anxious dark hours. A wild jungle of greens. Yellows, the pith of lemons, Brillat-Savarin, Naples, urine, sulphur, feathers and ancient gold.

In the gloom the shop assistant is looking at me from behind his heavy oak counter; he stands in his white cotton coat surrounded by jars and cabinets.

PLATE X

I am back in my father's pharmacy in that Kensington square. Those bottles, those cabinets, the grinding and mixing of coloured powders, a pestle and mortar are both here and there. He is about to serve a customer, perhaps a deposed Queen of Bulgaria, with ladies waiting, perhaps the hypochondriacal T.S. Eliot in black Homburg and overcoat is snuffling there. 'The chemist said it would be all right, but I've never been the same.' The assistant looks at me. Dust to dust.

PLATE XI

Wednesday, 4 August

I wake up to the sound of sweeping and weeping from the courtyard.

Odile Hellier arrived precisely at 10 a.m.

My new pastels were in little cardboard boxes with sawdust.

Odile Hellier runs the Village Voice bookshop just across the Boulevard St-Germain, in the rue Princesse.

I arranged the pastels in rows on the table in my drawing-room.

PLATE XII

It's called Village Voice because Odile spent twelve years in America in the 60s and 70s and admired that once-radical newspaper.

The room is on a corner and light floods in from four large windows.

Odile was homesick for France, but admired the vigour of American authors and opened the best English-language bookshop in Paris ten years ago.

I clipped a sheet of paper to a board on my easel.

Odile sat down and began to read a new novel she had just received. She has new and interesting books all the time, from both Britain and America. She reads a lot.

She was wearing a sienna brown shirt, her hair scraped back in a bun, her eyes mascaraed. I began to draw.

Odile is very popular with authors, she arranges readings in her shop.

Odile looks severe; she is fluent in Russian as well as English, she had just returned from a trip on the Volga.

I draw her eyes.

Odile has often been compared with Sylvia Beach, heroic owner of the original Shakespeare and Co., first publisher of James Joyce, she modestly demurs.

I draw her hair, the straight swan neck.

Odile is very composed.

I draw the line of her arm, her hands slightly touching the book.

Odile lives on her own with a cat, like Colette.

I draw the folds of her blouse.

Odile looks up and smiles in a mysterious way; perhaps she has a secret.

Later that afternoon, *between cinq et sept*, I am thinking as one does, about prostitution. Toulouse-Lautrec, the Degas monotypes, Dumas, Maupassant, Nana, Irma la Douce and Madame Claude.

The telephone rings. 'Hello my name is Julian More, you don't know me.' I don't, but we have a mutual friend and I invite him round. He wrote the stage musical, *Irma la Douce*.

Thursday, 5 August

Edmund White delights to write, he lives across the river.

Edmund White is homosexual and writes much about homosexuals. He writes short stories, novels and recently an enormous biography of Jean Genet. His writing is both sparkling and haunting. He lives in a large apartment near the gargoyled Gothic Tour St-Jacques, with his architect boyfriend, who is not well.

There is sadness here, but Edmund is very funny, his conversation priapic, gossipy and hilariously indiscreet.

A basset hound lollops in, so fat, so low-slung he ploughs a furrow in the carpet.

Edmund has a vague resemblance to Christopher Isherwood, who was an encouraging friend. His voice is southern, vaguely resembling that of Truman Capote, who was a friend. He is plump but doesn't resemble Genet, who was a poetic fiend. The patron saint of rough trade, betraying and biting each patronizing hand.

He is pleased to have finished with the tough and devious Genet. Perhaps Jean Cocteau next: 'Think of all those drawings.'

'Do you know Patrick Procktor?' I had a vision of the etiolated, lovable and talented Patrick.

Edmund enjoys 'Gay Paree'; he is left alone. 'It's not as exciting as the U.S. Who needs excitement?' He said wistfully. You do, I thought.

He told me a certain woman we both know, cool and respectable in appearance, was a sadist and twice a week was employed, by the ambassador of an Arab country, to be unpleasant.

A recent British ambassador, in contrast, had, as his only known vice, the penchant for his footman to hurl peanuts the length of a corridor in the Embassy, which he would deftly scamper after and catch in his mouth.

I think of asking Edmund if he knows what a *brioche maudite* is, but it is too disgusting and I continue to draw.

Edmund sat in a brown leather armchair across from mine, a net curtain fluttered behind him. He became less sparkling and more haunted. Did I approve of Dan Bachardy making those drawings of his lover Isherwood on his deathbed? Yes.

Did I know David Hockney? Yes. I know several David

PLATE XIII

Hockneys. I knew a witty, kindly Hockney in Notting Hill. I knew a laughing, flamboyant Hockney who one wet night, walking through Les Halles when it was made of wood, was groped by a woman of the street, and squealed louder than any of the victims of the nearby meat market. I knew a Hockney surrounded in his court high above Los Angeles.

Edmund said his Genet book had had one particularly caustic review. He explained something of the intricacies of a literary feud. I told him something I know of the homoerotic possibilities of Buckingham Palace – that cheered him up.

He told me his books have a surprisingly large following amongst Japanese teenage girls.

He told me of a conference in Key West. His kind of town, I would say. I'd been there.

He showed me around his apartment with southern courtesy. The expected Mapplethorpe photographs. The master bedroom where his boyfriend sleeps, his own small bedroom. His camp-bed.

I said I had to go as I was taking too much of his time. 'Oh no, I never do any work.' He has three new books coming out next year.

I like drawing writers, they tell you stories. What else is there? Otherwise we are just victims of grinding cycles of birth and decay. Bible stories, Karl Marx stories, Einstein stories, Stephen Hawking stories, distracting, inspiring or giving purpose by arranging the letters in alphabet soup.

Drawings are not truth either, they are constructions, more or less beautiful lies, more or less acts of faith.

As I walked home, past the conical towers of the Conciergerie, I thought of William Golding just after he had won the Nobel Prize. His house in Cornwall was a reproduction Normandy château with a beautifully tended garden. I stayed with him for three days of drawing and esoteric chat. Moses and monotheism, the sea, why Graham Greene had never won the prize, how Golding had written other and better books than *Lord of the Flies*.

I slept in a guest bedroom, where he pointed out a tiny plaque above a hole in the wall, just above the bed head. The legend on the plaque explained how General Eisenhower had used this house when he was planning the Normandy landings in 1944, and that one of his G.I. guards had run amok and tried to assassinate him just before D-Day. In the hole was the bullet.

There seemed to be a lot of books about the war on the *bouquinistes*' stalls, and then there were books about early cin-

ema. As I crossed the Pont-Neuf, a barge named 'Atalante' was passing underneath. I wondered if anyone on board was looking into a bucket of water to see the face of their lover.

I pressed my code and pushed open the heavy painted 'verte Anglaise' door. Upstairs in the apartment I was told that the pigeon that had homed to the windowsill to be fed for the past three years, had changed sex and now she had a lover.

I gave my lover the *puits d'amour* I had bought at the pâtisserie. It is an apple filled with raspberries encased in a luscious shortbread pastry. Its name means the well of love.

PLATE XIV

Friday, 6 August

I crossed the Pont des Arts in the morning sunlight. The prow of the island just upstream, Notre-Dame could be seen above the green candy-floss of trees on the Vert-Galant. Through the Pont-Neuf one could see the Pont au Change, through that, the Pont Notre-Dame evaporating in the yellow haze. The distressed golden dome of the Mazarine is topped by a little turret fit to contain a princess. The stonework of the Louvre is engraved with patterns like human brains. The Samaritaine department store as Deco as a glass liner, the fairytale towers of the Conciergerie that contain cruel memories of torture. A fly-blown bateau-mouche, a barge like a suburban house, with geraniums, trees in tubs, washing lines, and a motorcar on its deck. It sounded its mournful siren as if it were being captained by Puccini. Monet's poplar trees swayed on the banks, lovers kissed on the quays.

A painter moved his brush over a large canvas of this divine scene. I recognized the painting, it was dry. Last week it was being painted by someone else, the week before that by someone else. There were smaller canvases for sale.

I passed a young woman who was walking ahead of me across the bridge. French women dress from the back and like turned playing cards, the face value is often a surprise – she had become an elderly lady.

It's the cut. Hair, clothes – the Parisians are very skilful with scissors. They like to cut each other too, to snub, quick flaring quarrels. Their *amour propre* is a fragile thing. Their first response, 'Non, impossible', is a bargaining position. 'C'est pas ma faute' echoes through the streets as cars crash like dodgems.

On the Quai du Louvre a car nudged a motor bike. As the biker got up off the road I was surprised to see him pull a knife from his boot. The car driver saw this and ran back to his car and sped off.

In the Tuileries was a fairground. It camps there each year in August. It is a real fair with dodgems for drivers to practise on, a Ferris wheel you can fall out of, a wooden helter-skelter (a more elegant version of the architecture of the Pompidou Centre) and a ghost train.

I know about ghost trains. One summer while a schoolboy, I worked on one, helping people into cars and damping, dangling sponges in the haunted house. Ghost trains are more frightening with the light on.

There is a plaque on the corner of the rue de Buci and St-Germain which says:

ICI A ÉTÉ TUÉ
FRED PALACIO
CORPS FRANC VICTOIRE
C.D.L.R.
POUR LA LIBÉRATION DE PARIS
LE 19 AOÛT 1944
À L'AGE DE 21 ANS

PLATE XV

PLATE XVI

There are plaques like this all over Paris. Near Armistice Day and on anniversaries they are decorated with tricolour ribbons and poignant bouquets. I read them all, half fearing to see one that shares my birth date. The French have had little success at war since Napoleon.

A friend, the 'Bird', came round for supper. She brought with her two rather good bottles of claret, some fruit and an ex-rock star.

PLATE XVII

PLATE XVIII

The ex-rock star had lived in Paris for twenty-five years, near Père Lachaise Cemetery, where Jim Morrison, a decidedly ex-rock star, is buried. Fans take drugs, drink and copulate on his grave through the night and 'dread the milky coming of the day'. He is an object of cultish veneration in Paris. The ex-rock star who knows about these things said Jim Morrison did not die in his bath, as legend has it, but died in the lavatories of a nightclub in the rue de Seine. The owners, for fear of scandal and closure, insisted his friends put the corpse in a taxi and go away.

Père Lachaise is extraordinary, like a bizarrely beautiful nineteenth-century model village. It looks even more haunted when under winter snow. It is visited by the sad, the mad and the bad, and maintained by hundreds of wild, spectral cats.

Oscar Wilde, who died in the rue des Beaux Arts, near the rue de Seine, is also buried there. The night after he was buried someone stole the penis from Epstein's monumental tomb.

Abélard and Héloïse lie there together. Poor Abélard lost his penis by castration before he died, hence the poignancy of their love. Why this story should appeal to people as lecherous as the French, I am not sure.

The ex-rock star had theories on social climbing through rock and roll. We discussed Freud's dictum that artists (I presume that includes rock stars) wanted fame, money and beautiful lovers by illegitimate means.

He spoke of William Burroughs and his penchant for shooting things. I remembered meeting William Burroughs a year ago in Paris. He had an exhibition of his collages, which were distinguished by a bullet-hole in each. Maybe after the unfortunate 'William Tell' episode with his wife he thought he needed more practice. There was a party after the opening in an apartment on the Quai Voltaire.

We were talking of Tangier and Francis Bacon; Burroughs was eating a hard-boiled egg.

I said I would like to draw him, he should have lunch with me, he could be naked if he wished. A cold, queer, undersea junky stare came from his skull; there was no time, he was returning to the U.S. the next day.

The ex-rock star reminisced about his days on the road, and ate rigatoni prepared to Paolo's recipe. Paolo is a jovial Italian, a retired stomach surgeon, now a dealer in musical instruments and particularly familiar with Stradivari. From gut to cat gut.

Saturday, 7 August

The tarmac is melting on the rue Montmartre. It is silent, still, like a plague city. In the heat flocks of pigeons fly above, leaving moving shadows on the road as if of fish swimming in a grey river. Golden horseheads stare from above the red-shuttered butcher's shop; all apartment windows are closed against the searing sunlight. Through a yellowed glass shop window, headless figures dressed in black lace basques tilt and idle as if in a brothel, telling of the impermanence of erotic love.

'Isn't life strange,' said a voice. Two Americans in Paris climb the hill to Montmartre reading a map and eating plump baguette sandwiches, movable feasts slouching towards Byzantium.

The streets, once empty as a film set, are now crowded with extras dressed as tourists. The sugar-white Byzantine basilica of Sacré-Cœur lies painted on the powder-blue sky.

In the Montmartre Museum nearby is another film set, the reconstitution of an artist's studio, Paris in the 1920s.

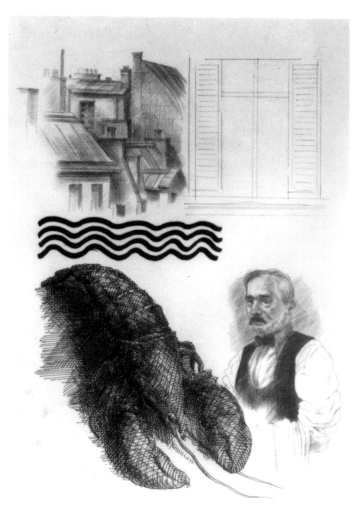

PLATE XIX

PLATE XX

Jules Pascin was a darling of the *années folles*, an alcoholic, erotomaniac, a hero of *l'École de Paris*, contemporary of Modigliani, Kisling, Foujita and at one time fetching better prices than Picasso. The archetypical studio furniture, palette, brushes, model's couch, an incomplete canvas on the easel are there, the perfuming bottles of turpentine and wine, a wind-up gramophone to help animate all those depraved parties.

He was taken to a Turkish bathful of houris by his aunt when a child. He lived in a brothel at sixteen. He came to Paris at twenty. He left behind many delicate, evanescent drawings and too many sickly paintings, watery nudes viewed through a kind of mist, as if he could never leave the hammam from his past. He finally found the door in that steamy room. He committed suicide at forty-five.

Every day is Christmas Day in the basilica of Sacré-Cœur. The infant Jesus, candles, incense and golden-winged angels. Ushers hush the shuffling file of tourists. There is a recording of choir-boy muzak, which not all the visitors hear because of Walkmans in their ears. Video cameras and souvenirs impede progress around this department store of piety.

The view from the steps is much godlier, Paris spread below. Churches stand out like rocks on a tidedrawn beach of silver, grey and sand.

I would have those angels' wings, in a different scheme of things. I would swoop and glide and fly across the streaked and scumbled sky. Through blue cross-hatched with vapours, to be lifted by thermals and carried by zephyrs over the lead roofs, and I would in turn touch each church tower, making each bell ring. Sainte-Chapelle, St Julien-le-Pauvre, St-Sulpice, St-Germain-l'Auxerrois, St Roch, and land at the Elysée Palace to offer one of my wing feathers to the President. A medieval king of France once paid the equivalent of £10 million for a single feather, which he was persuaded had come from the wing of the Angel Gabriel. I would sprinkle the gold coins on all the poor who huddle in doorways and sleep on the warm gratings with little cardboard placards saying, 'For food. I have no work. No home.' They would all go off and eat sumptuous dinners at Taillevant or Le

Grand Verfour or La Tour d'Argent, or Lucas Carlton and taste a glass of Château d'Yquem, which is the colour of this summer Paris day.

I walked down the hill, slowly home, through warm remembered streets.

The pleasures and the evenings. This evening there was a dinner at the Princess's. It has been noted that the end of the twentieth century is not quite the same as the end of the nineteenth century, but in Paris there are still some salons, after a fashion.

'Monsieur is afraid of the scent of Princesses,' Proust's servant said to an unwelcome guest. I am not, as here I can remember some of the most amusing times I have spent in Paris. The Princesse and Philippe, her younger, long-time lover, occupy an artist's studio at the top of a grand apartment near Bon Marché.

Her soirées, usually on Saturday evenings, are unpredictable, occasionally unbalanced, often unforgettable and therefore unmissable.

The Princess and her younger man are financially secure and spend much time travelling the world's grander hotels, improving their minds and their suntans. In Paris they keep fit for their social life by daily visits to the gym.

The Princess is a certain age, slim, brown, petite, chic and charming as befits a Parisienne. She dresses expensively in silken blouses and well-cut skirts, and is an interesting and generous hostess. Her young man is wiry and muscular, which he needs to be because occasionally he has to steady guests.

The blinds are never drawn in the studio, the lighting is Proustian and dim, and therefore flattering to all attending.

There is a large reception room with soft, chocolate-coloured sofas. Large palm trees fill part of it like an Amazonian jungle. Thousands of books line the walls.

The guests who gather here are a mixture of middle-aged gentlemen – with or without their catamites, as befits – who are for her, and pretty young girls to make a change for him, and random creatures who someone thought might amuse.

On my first visit to her salon I was introduced to one of her guests, a chic, distinguished middle-aged woman who handed me her passport with one hand and lifted her blouse with the other, to display her perfect torso, and said, 'I expect you are surprised by my age.' I was.

Conversation is conducted in a combination of French and English, salacious and full of innuendo.

On another visit I was introduced to an immaculately dressed

young man, who, before hearing my name, dropped to his knees. He was a minor aristocrat, and a staunch royalist. In the half-light, it appeared I resembled one of the two potential, ever-hopeful, ever-feuding would-be kings of France.

Titles waft around the room: the aristocracy, in spite of the revolution, still lingers and reveres itself in French society. Not all are genuine, social advancement with dubious entitlement has a long novelettish tradition. A stiff-backed blond young man cut a great swathe here and throughout Paris as a member of the Russian aristocracy. He had gathered an encyclopaedic knowledge of all the climbable family trees. He was last heard of in his native New Zealand, still in possession of the paintings he had offered to sell on behalf of some good families.

Another, an Englishman, a product of Dr Barnardo, his name still enough to shiver a room, lived very well for several years in Paris by the expedient adoption of a title.

This kind of thing works everywhere. James Lord, the fine biographer of Giacometti, an American long resident in Paris, and an old friend of the Princess, said he had much better treatment in London when his name was mistakenly reversed.

The revolution might have eaten its own children but the aristocracy lives on in France, favouring its members, who plot and yearn as if they were revolutionaries themselves. As they no

PLATE XXI

longer have one in functioning form they are bemused and fascinated by the behaviour of what is called the British Royal Family.

French society can be unbearably formal and stuffy. In some circles it is necessary that any remark be followed by describing it to be of the first, second or third degree of humour, not a humorous idea.

Not so in this salon, where you might find yourself at table with the literate or the louche or the lunatic.

The food served is invariably delicious, apart from the unique terror of *Ris de veau*, that dish beloved of the French, but in appearance so reminiscent of the surgeon's waste bin. This does not dampen the hilarity, as the Princess has unusual methods for those who fail to enchant.

This evening a woman was invited who had not been seen for several years, during which time she had become quite a rabid 'born-again Christian'. She harangued the guests during dinner about their various wickednesses. The Princess beckoned her to another room explaining that she had a specially made video for us to see; it was in fact the highlights of a late-night TV channel. The woman stared in disbelief at the swirling *mélange* of genitalia, screamed and ran from the house.

The conversation returned to the normal subjects of polite society, voodoo practices in Haiti, the private lives of French ballet stars, methods of torture in ancient China, who did what to whom in post-war Paris, modern New York and London, and why and how. Fun *de siècle*.

PLATE XXII

29

PLATE XXIII

PLATE XXIV

Sunday, 8 August

Summer in the city. I take my hangover to market – perhaps I can exchange it.

The rue Dauphine offers much amusement. At one end is the river Seine, there is a debauch of bars and restaurants, two nightclubs, Ruby's and Le Tabou, two hotels, seven boutiques, three galleries, two pharmacies, one lingerie shop, two delicatessens, two bookshops, two patisseries, and at the other end is the Buci market, which leads to the Boulevard St-Germain.

The Tabou was very famous in post-war Paris as a haunt of St-Germain's existentialist philosophers, poets and singers. For a time it was the centre of the known world. Today it is still a nightclub, although of a more mundane character. A black-walled, tubular cellar, pulsating with a disco beat, sweat running down the walls. Now on Sunday morning it is silent and exhausted, its door closed at dawn.

In the Buci market, near the flower stall beloved of tourist cameras, past the Atlas Brasserie, between the wine shop and the side door of the supermarket, sprawling on the pavement are three *clochards*.

They are eating baguettes and sharing two litres of red wine from a plastic bottle. They lie on dirty blankets, their meagre possessions in plastic bags around them, they have a primus stove and a mangy dog.

As I glance at the English papers in the rack at the newsagent, I cannot help but overhear odd snatches of their conversation. 'Man is condemned to be freed,' says a gnarled old man in a tweed jacket, a cracked pipe in his lips, thick glasses bound with tape in front of bulbous swivelling eyes. 'You know. He draws his own existence.' A stiff-backed old woman, toothless, grey hair scraped back, scratches herself, spits on the ground and sneers, 'Fuck men, we always come second to them, shit.' She passes the bottle to another man lying in a dirty fawn raincoat. He gulps down the wine. 'Hey, take it easy.' 'Fuck off,' he snarls, 'a plague on all of you, with you I always feel I'm on the outside.' 'Drown in shit, you old fart,' says the old woman. She lights a dog-end from a collection in a plastic bag. 'I was once a dutiful daughter.' 'For fuck's sake you make me nauseous, you slag,' said the man with the bulbous eyes. 'Go fuck yourselves, I'm sick of being in this nothingness.' He farts. I step delicately over the outstretched legs and go round the corner to look for food.

Food, the Buci market has glorious food. To step into the

PLATE XXV

PLATE XXVI

PLATE XXVII

PLATE XXVIII

street lined with these stalls is to enter into a living, bursting cornucopia. An enormous *ratatouille* of vegetables, a flocculation of poultry, chickens, quails, partridges, turkeys. A blazonry of bouquets, lilies, roses, irises, tulips, anemones. An intricate collocation of cheeses from all those little farms all over France. Whole abattoirs of beef and pork, offal and brain, trotters and testicles. An inebriation of wines, all regions acknowledged. A patchwork of pâtés like house bricks, vast erections of baguettes, and ovenloads of country breads. A frivolity of fish, an ostentation of oysters, crabs and lobsters and an endless fandango of fruit.

A boulevard of *boudin*, a plethora of pastries, an orgy of olives and a palaver of pies, from which I select a *tarte à l'oignon*, and take my hangover home.

I push open the green door and climb the stairs. The stairway would serve as a backdrop for a Simenon novel. The concierge's lodge, the word 'Concierge' ornately etched in the glass. The brown and cream walls, the dark waxed parquet stairs with the decorative iron banisters and the wooden rail, which curves like a serpent, up through the building to the tiny *chambres des bonnes*. Here live the careering students and the eloquent hunchback, whose manners and dress speak of another time.

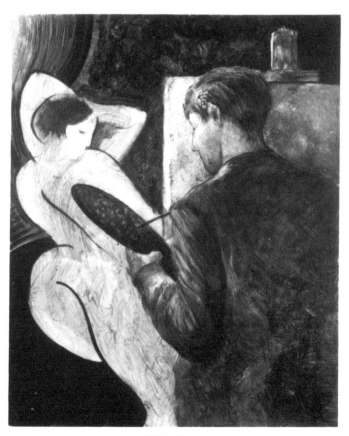

PLATE XXIX

Monday, 9 August

The sun shone through the open windows, weaving four golden carpets on the parquet floor. I drink coffee and sharpen pencils. 'We draw our own existence,' said Sartre, defining existentialism. I am about to draw my existence and the existence of my model.

The model is in front of me, I look up and see, and with the fine point of my pencil I draw the line of a single hair. Which is simultaneously a hair lying on the paper, a description of the model's hair, a definition of the outline of her head, a pencil mark on paper, the record of a point moving in time, observation filtred through temperament, a metaphor, an imaginative lie, an act of voyeurism, a portrayal of gesture without motion, stroking, the possession of a soul, a refraction, a reduction, an act of love or just a drawing.

When it is finished, I go out to a café.

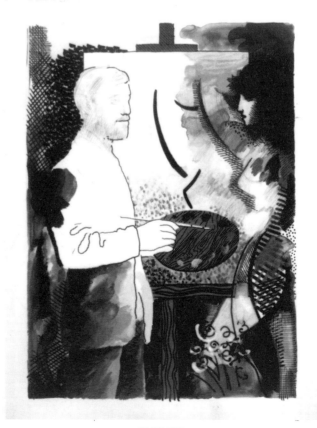

PLATE XXX

I was woken by an eviscerating scream from the street – it was two o'clock in the morning.

In the moonlight, a black girl, glistening bouffant, tight glittering pink dress and white stiletto shoes, one of which was being used to beat a bemused shiny-suited business man, who was pulling her towards a waiting taxi. Two vast bouncers appeared from the doors of Ruby's nightclub; they communicated their disapproval and the man, cursing, went off alone in the cab.

Nothing unusual about this. The affability of the girls who work in Ruby's and allow gentlemen to buy them quantities of obscure champagne is often misinterpreted. It should be obvious to anyone that it is the duty of these girls, who mostly resemble members of the 'Three Degrees', that, having emptied one gentleman's wallet, they should not go home with him, but return to the club and empty that of another newly arrived and more deserving of their attention.

PLATE XXXI

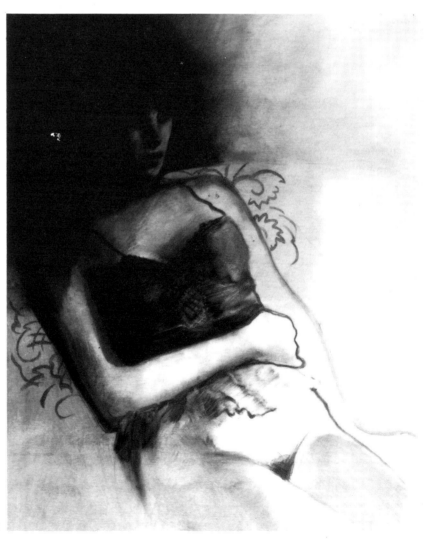

PLATE XXXII

36

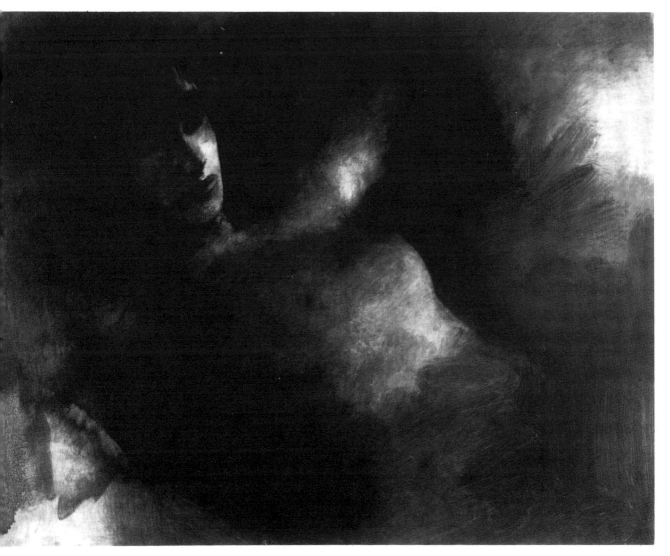

PLATE XXXIII

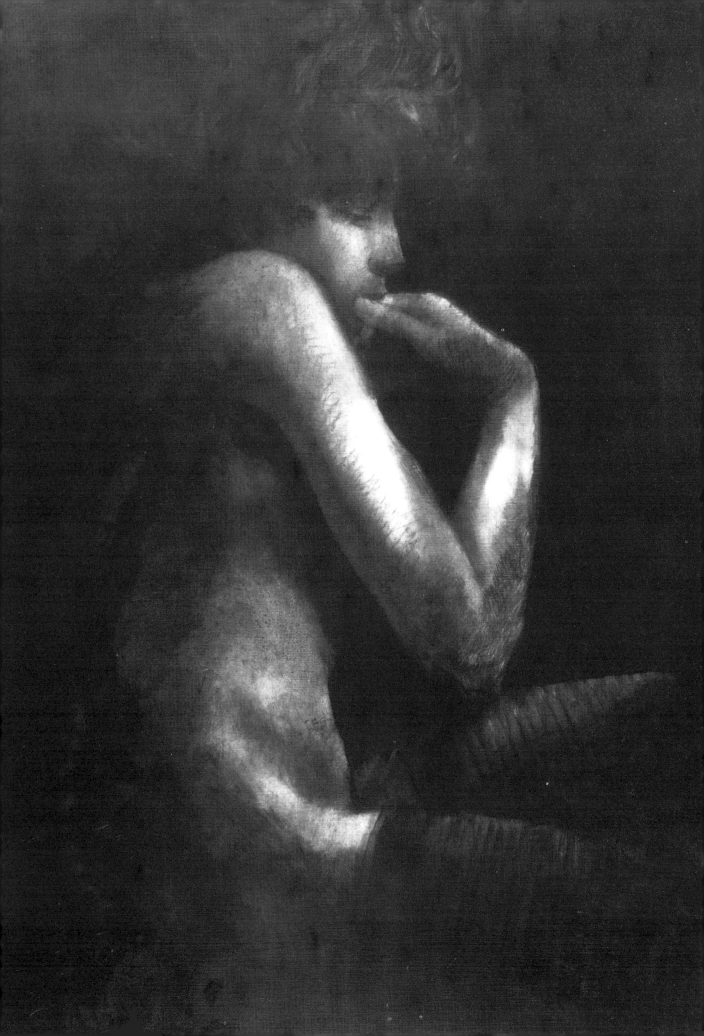

Tuesday, 10 August

Did Nazi troopers ever storm my stairs? My fourth floor corner window is ideal for a Resistance sniper's rifle. Or did some tall, grey-uniformed officer arrive bearing flowers and cigarettes, silk stockings and sausage?

A French woman of my acquaintance told me it was lucky that she was in Washington during the war, typing for the Free French, because she thought that the Germans in the photographs that she had seen were so attractive, 'especially their boots'.

Anthony was tall and blond, but very far from being a Nazi. He was one of the sons of a powerful political Washington family and he came to France to get away from who knows what, and then stayed. He worked as a furniture restorer, he worked with some of the excellent craftsmen that Paris still has and he learned much. He liked to work with his hands, even though he had had the sort of expensive education only America can supply. He liked to lay the wafery, fine beaten sheets of gold on to fantastically carved rococo picture frames, to restore fine hand-turned chairs to their plush, lush gilt. He liked mixing rabbit glues and sizes to ancient formulae and waxing, polishing, dis-

PLATE XXXV

PLATE XXXVI

tressing and buffing, and using all the alchemies of a craft that put him in the same place as, and using the same materials as the master craftsmen of the seventeenth and eighteenth centuries.

He worked in a pretty white-washed studio in Montmartre, in a cobbled courtyard dripping with ivy and grape vines. It was far from Washington.

I went to see him there one day for lunch. There was a large wooden table set in the courtyard under a chestnut tree, covered with wine bottles and all the good things that French craftsmen like to eat.

After lunch we went into the studio where he showed me odd mortise and tenon joints and locking wooden pegs that no one can make any more.

The workshop was crammed full of gilded furniture, an-

PLATE XXXVII

Right: PLATE XXXVIII

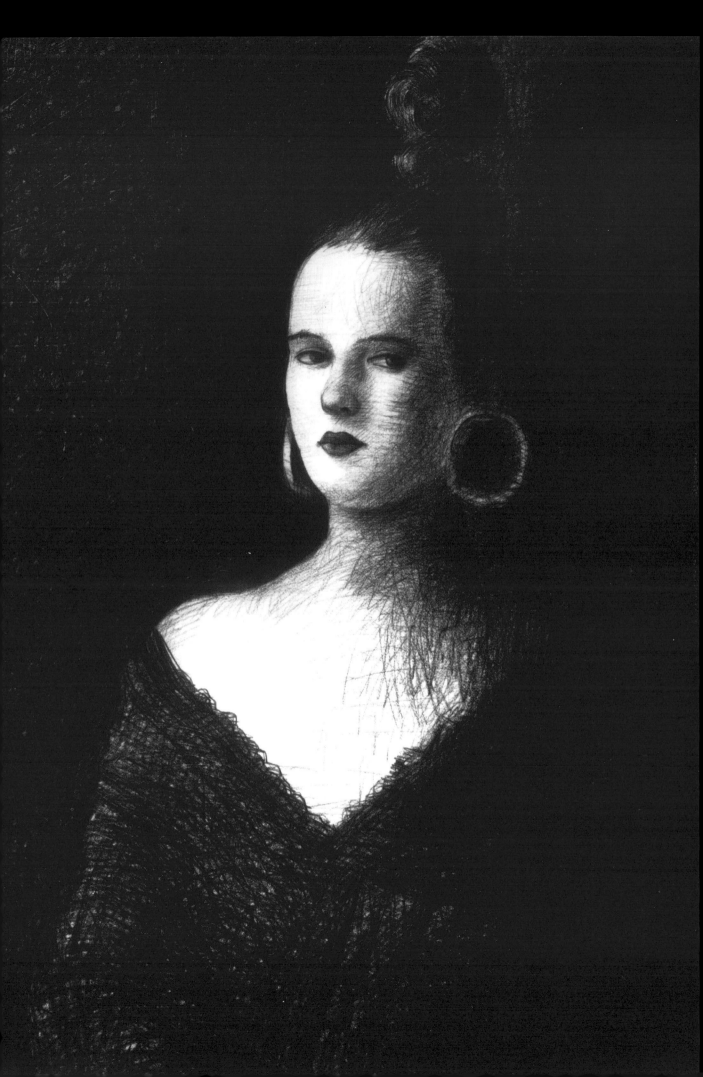

tique templates and frames stacked deep against the walls, glowing gold enough to satisfy Howard Carter.

'I have a surprise for you,' Anthony said and showed me a large iron key. I followed him outside to an iron staircase which led to the upper storey of the building. He unlocked the door into a dark, dusty apartment. It was an artist's studio; there were canvases hanging on the walls, easels, plan chests bursting with drawings and yet more drawings in rolls. A cracked palette on a stool, an overstuffed armchair, a plaster cast of a large plump Cupid and a violin case. The paintings and drawings all had a free touch, brush marks dabbed and cross-hatched, or rococo curves and twirls, which echoed the furniture being restored in the workshop below. Decorative yet sure. There were textile designs on paper and printed on fabrics. It all appeared to have been undisturbed for forty years.

This was the case. Due to one of those ceaseless litigious family disputes that seem to mark the end of artists' lives, it had been left intact, like Tutankhamen's tomb, guarded by the craftsmen below. It was Raoul Dufy's studio.

Anthony lived dangerously outside his work. He would sometimes get into trouble in bars, which surprised me as I always thought of him as gentle, if slightly crazed in the way many Americans are. He was playful at parties, he had a sweet English lover and a cat, and a cottage in Normandy.

One day he was dead. An absurd accident while working in a château.

The funeral, in an old church, in grey mist, one morning near all those war cemeteries in Normandy, was too sad for these words. His lover was very brave and dignified; with her pretty high-domed face, she looked like a child's doll dressed for death.

I always smile when I think of him, he had true *joie de vivre*, and not everyone has that. I imagine him now carefully and beautifully restoring and gilding harps.

PLATE XXXIX

Wednesday, 11 August

Stormy weather, the sky is pewter. The stones of Paris, as sensitive as chameleons, mute their creaminess.

I cross the Boulevard St-Germain, up the rue de l'Odéon, past the sight of Sylvia Beach's bookshop, past the sight of that of Adrienne Monnier, her intimate friend. The Méditerranée restaurant is closed, the blue-waved fascia and awnings flap in the wind like the seaside on a winter's day. The lobster tanks are empty. Through the windows the strange grey-black rooms decorated by Bérard and Vertès are still, the Cocteau menu unread. Past the Odéon theatre, the neo-classical temple where revolutionaries debated to a background of sirens, tear-gas and flying cobble-stones during the events of 1968. The streets of Paris have been tarmacked since.

Into the Luxembourg Gardens, past the dark fountain, the Italianate Medici Palace, both solid and frivolous. Around the pond small children, some in sailor suits, prod sailboats with

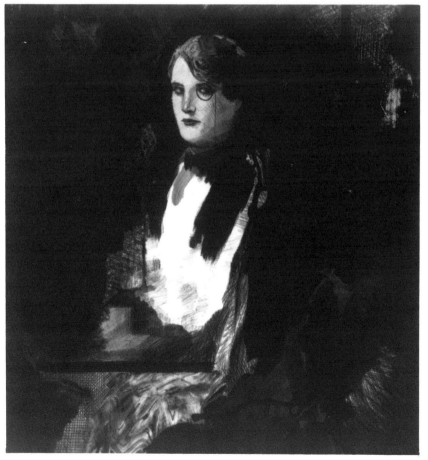

PLATE XL

43

PLATE XLI

sticks, towards the fountain in the centre. The overflowing urns, flowers luminous pink against the viridian trees. Underfoot dazzling gravel crunches with a sound that leads you to expect to find seashells or starfish lying there. There are surprising palm trees, a badge of climate, horse chestnuts, boxed and geometric, a symbol of the never-ending attempt to order unruly, seething nature. Through the majestic gates into the funereal avenue de l'Observatoire. Sombre, it induces an exquisite melancholy, sweet pain, a tongue pressing on a loosened tooth. Umber leaves fall, reminding like a ticking clock.

Outside the Closerie des Lilas, Marshal Ney still brandishes his sword, which should please Hemingway. The boulevard du Montparnasse is Sunday quiet, still as a black and white photograph of the 'crazy years', but the players of the time might be surprised by posters for phone sex – but not phone sex itself, or fast food, or roller-skates, who knows, many were American.

To prolong my elegiac mood I take it where it deserves, to the Montparnasse Cemetery. A map is issued at the gate, a mor-

bid version of those tours of stars' homes in Hollywood. There is Huysmans down there, Baudelaire, calm, Beckett waiting, there are Sartre and de Beauvoir being nothing. Two Italian boys ask me, 'Where is the grave of Jim Morrison?' They are in the wrong cemetery. Colonel Dreyfus is accusing here (his problem still disturbs the French), Man Ray is here, his shutter closed. Pascin, another wandering Jew at rest, his grey-rocked tombstone engraved in gold with one of his drawings.

There are tombs, vaults, sepulchres, mausoleums, some like stately homes, some like dog kennels, vainglorious, desperately pleading 'Remember, please remember'.

The great artists' restaurants, the Dôme and the Rotonde, on the boulevard du Montparnasse, are sleek and expensive, no longer fit for intrigues, feuds or love. No longer venues for revolutionaries with paint brushes or grenades. Lenin plotted in Paris and worked occasionally as an artist's model; it amuses to think that somewhere there must be drawings of his poses.

One can still eat Welsh Rarebit in the Sélect, a recipe learned in the 1920s from a homesick Englishman, but improved with Breton cider. I sit at a round, brass-rimmed marble table on a wicker chair on the terrace and drink a beer, and muse on Kiki of Montparnasse, famous artist's model, lover of Kisling and Man Ray and many others through those years.

Across the street is La Coupole, bar Americain, brasserie, restaurant, dancing. The biggest and most famous brasserie in town, where Sartre is supposed to have spent his last years in the company of a young Algerian girl who barely spoke any French, and where he would infuriatingly ignore all his philosophical friends and only address his genius to her.

La Coupole, all those drunken meals in the company of the beautiful and the clever and the vicious. Although I have only been there once since it was cleaned up for the 1990s. Perhaps when the patina returns.

Champagne and oysters poured into Sam White by grateful waiters. Somehow an anachronistic myth had developed that he had liberated La Coupole at the end of the War. He was too kindly to disabuse.

Once I found myself sitting next to a painted and powdered elderly lady beneath one of the painted columns. She reminisced, saying she had posed for the picture on the column way back when, and how the artist had loved her, and how the war had so cruelly separated them, but that was how it was. I could only see a landscape.

Downstairs they still have the dancing, there is a *thé dansant* every afternoon in the basement. While upstairs the beau monde of writers, politicians and dress designers eat and drink and look

at each other, downstairs the *petit bourgeois*, those who have not left town, take measured steps. They are solid citizens with tight suits, new perms and proper frocks, and proper jobs, swaying in a world of the 1950s to live musicians, including, as one would expect, an accordionist. They are not interested in the people upstairs, with their deals and suicides and affairs; they dance in the dark under dangling silver cut-out stars.

They are respectable, bespectacled, middle-aged couples, and for the widowed or divorced there are taxi-boys who can be hired per dance by the lonely. It is an enchanted world, where they shed thirty years for the price of a ticket and turn daylight into midnight and romance.

This evening at midnight, I went with my lover to the Pont des Arts, where there was great excitement as there was a shower of meteorites to be seen. The wooden bridge was covered with supine bodies staring at the sky. Thoughtful youths climbed lamp-posts and gingerly loosened the bulbs to diminish the city of light and hence make the stars shine more brightly. 'Wheeeeeeeeee there, there, no there,' shooting stars brighter than fireworks, threw trails of silver across the sky. A young man stood precariously on the railing conducting an orchestra only he could hear, and then jumped into the Seine with a great splash. Everyone rushed to the rails, but he swam safely to the bank, crawled up some steps and there vomited buckets.

There was a perfect crescent moon pinned to the black night sky above the Louvre. So we went to the all-night baker in the rue de l'Ancienne-Comédie and bought an almond croissant, shaped and powdered like that moon, and ate it.

On the pavement, still wrapped in cellophane, thrown perhaps in a lover's quarrel, was one perfect red rose.

Thursday, 12 August

I watched Marylin Monro coming down the street, the clatter of her heels carried up to the window. She tripped briskly, her blond hair bobbed up and down, her little dog trotted on its lead. People turned and stared.

Marylin unbelted her white silk coat and smiled a coquettish greeting through her long eyelashes. She then undressed the dog, first its yellow leather jacket and then each of its miniature drawstring matching leather booties in turn. She touched up her lipstick. She was wearing a tight, sleek, black sheath-dress and knife-sharp stilettos. We discussed her career. It was not so easy since the nightclub had closed, but she had great hope for a recording she had made recently. She still had some cabaret work in the hotels in the Caribbean. In the nightclub she had been a real star, she sang, danced and for a magnificent finale descended naked to the stage on a glittering, sequinned crescent moon.

She is petite and fine-boned with a fragile femininity few could rival. One has to look very hard to see the slight indentations of her beard.

She was never happy being a boy in Algeria. Her family were *pied-noir*; she went through the motions unconvinced. It was the seduction by a man in a vineyard which left her so confused that made her come to Paris.

Here she met Martha. Martha was an American lesbian who taught English – well, Brooklynese. Martha encouraged and paid for Marylin to go to New York and have what she no longer needed removed. Marylin was so grateful she discovered she loved women after all, and she loved Martha.

They lived together in Montmartre, and because they both occasionally felt the need to love men as well, they would sometimes call the fire-brigade to non-existent fires in their flat. The firemen of Paris are brave and used to this sort of thing, and, in the line of duty, quenched the fires of the two women.

'It was the helmets.' The Paris firemen wear wonderful, shining brass helmets like Greek soldiers; they are known as *pompiers*, the style coming from the neoclassical painters of the last century.

Art and life can be wonderfully confused. After a time Marylin decided that she really liked boys, and left Martha amicably, who in turn married an effeminate man. Marylin now has a young lead guitarist as a boyfriend, who knows if he knows. She seems happy enough with a life to rival Orlando's.

Marylin went off to do something musical and I went off to be nostalgic. Paris can be remarkably poignant for no immediately apparent reason. Glimpses into courtyards, doorways, ivy-clad walls, those strange views down narrow curved streets, the odd refractions of sunlight. The shops are determinedly independent, selling the materials to continue activities that one thought had long since ceased.

Things change. A little old baker in an ancient tiled shop has disappeared from the rue de Seine, and the man who pored over and rarely sold autographed letters, Victor Hugo, Napoleon or Gide, from a tiny cupboard in the rue Dauphine has gone. His shop has now been bricked up.

Maybe it is my past, maybe these back streets have changed much less than those in London and somehow invoke my childhood.

There are many places in my *quartier* that have the delicious slightly sour flavour of *crème fraiche*. The Place Fürstemburg, the rue Visconti which insinuates from the rue de Seine to the rue Bonaparte. On the corner is the peculiar restaurant which is strictly divided into three floors, the main one for girls who prefer girls, upstairs for boys who prefer boys and a basement for anything uncertain or unaware.

Behind St-Sulpice are streets that would serve as suitable stage-sets for all the varied terrors from Paris history. St-Sulpice itself, overbearing, asymmetrical, its bell inscribed *pacos cruentos* – 'I pacify the bloody disorder' – rings out over the Place St-Sulpice with its fountains rippling over wet lions, its shops selling the paraphernalia of worship; could well be Rome.

Idling from here to the Luxembourg Gardens is the rue Ferou, with Man Ray's old studio, from where some insensitive tried to evict his elderly widow.

There is a hint of magic in these strange streets, some black, as expected in a Catholic country.

PLATE XLII

48

Friday, 13 August

I did not recognize Jean-François at first, I had only ever seen him in his white shirt, black waistcoat and long white apron. Then I heard the familiar tones, 'Hello Big Boss.' 'Hello Jean-François.' 'I am vacating my holidays.' This is a shame, because Jean-François runs La Palette, the favourite local bar. Years ago he was a good-looking simple barman, now he is part-owner and the pavement is his theatre. He is a large, rough-bearded Breton, who has a subtle system of domination, serving or ignoring according to his taste. Sometimes he will abruptly empty a table of tourists to make space for people he finds more congenial. He looks not unlike Pavarotti and has an operatic temperament to match. Early in the evening, much hand-shaking or kissing as appropriate; as the night goes on and he has helped with the emptying of the bottles, a more lascivious embrace awaits the prettier girls. He is emotional and easily hurt. Any unexplained absence from his bar for more than a week will be considered an act of infidelity, and much time has to be spent explaining one was in America, or London or anywhere but not in some rival bar round the corner.

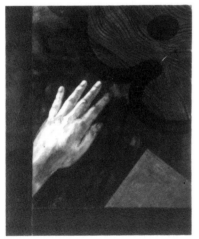

PLATE XLIII

La Palette is a very pretty bar, as a Paris bar should be, trees and flowers outside, green awnings, a smoky, tobacco-stained back room, and a revolting Turkish toilet, which he refuses to change.

It is decorated with artists' palettes signed by not well-known hands and it has columns painted by not well-skilled hands, but the place has immense charm and many people have had much amusement there.

It is well known even by the President, who last year sent a group of American Congressmen and their aides, following a NATO meeting at the Élysée Palace. The debauchery that night – I am ashamed to say, encouraged by my friends – left one aspirant President from somewhere in the Midwest in a condition of such disarray that it provoked his aide to whisper to me how he wished he had a camera, as he would then have his master's balls in his pocket, 'all the way to the White House'.

Francis Bacon would occasionally trip by, in his basketball boots, wearing his baby-face and leather jacket. He was very popular in Paris, for Bacon's existential meat reminds them of things they eat.

Jean-François counts his money with the eager greed of a peasant. His bills are whimsical affairs, no written evidence, just a memory which is as mean or generous as his mood.

There is much diversion to be had in this *quartier*. L'Oiseau de Nuit in the rue Mazarine is a bar that does not really come to life until after the Palette closes at 2 a.m. A small window in the street door will slide open like a speakeasy in Chicago, and if you are suitable, you will find some of the insomniac detritus of the city.

Performers from nightclubs in the city will sing one more time around the piano, still feathered and made up, in a room like a ghastly blue neon-lit tube train. Malcontents and people with no content whatsoever, the deviant and the enchanting, drift in the *bateau ivre*, buffeted by troughs and peaks, by sudden storms, thunder, lightening and nauseous squalls, will be becalmed to silent attention when the owner takes the microphone and yet again renders Jacques Brel's 'Port d'Amsterdam' with bulging eyes, stamping foot and throbbing arteries, until one can take no more.

PLATE XLIV

Saturday, 14 August

I worked happily until tea time and then bought a cake. A *mille feuille*, thick with caramel and pears, from one of the fiercely competitive patisseries on the Buci market. Then I took a benign stroll down to the river and across to the Île St-Louis.

It is forever being repeated that when good Americans die they come to Paris. I think they would have to be very good indeed to live in the Hôtel de Lauzun.

The Hôtel de Lauzun is a seventeenth-century town house on the Quai d'Anjou. Unpredictably opening to the public, it has been restored to wonderful effect. Floors, walls, ceilings, furniture, all carved and painted and encrusted with golden fruits and cherubs, with an Italianate sumptuousness. A fairy-tale, for once made real. Sometimes used by favoured state visitors, our own dear Queen must for once have felt herself in a fit setting. Her delight would have been further heightened by the knowledge that this was once the meeting place of the club *des Haschischiens*.

Baudelaire lived here in the *chambres des bonnes* beneath the roof in the 1840s. Soirées were disordered, new worlds and artificial paradises glimpsed with the aid of pellets of green hashish, pipes of opium and exotic alcohols.

Baudelaire, a poet, art critic, dandy, perverse lover of a mulatto mistress, drug addict and whining waster of an inheritance, was almost too Parisian for words, except he had words.

The elaborately restored and decorated rooms, even without narcotic assistance, are hallucinogenic and dangerously incline one to reveries of Théophile Gautier, Delacroix, Chopin, Madame Sabatier and Jeanne Duval, languishing amongst the Pompeian half-beasts of green, yellow, red, black and gold.

I am released from my transports by the guard sounding a bell at closing time.

For supper my lover cooks a gigot of lamb, with garlic, honey and rosemary, and concocts a vegetable dish of mashed potato and leeks with chèvre cheese grated and stirred into it.

The wailing sirens bring me to the window at midnight. There is a line of helmeted, visored men in blue uniforms, with shields interlocked; are the Romans back in town? There are grey corregated vans with wire windows and rotating, flashing blue lights. Behind the first phalanx, a legionnaire attaches something to a sling shot. They advance in a line, beating their shields with their swords, on a crowd of Gauls, the object of their desire.

The Gauls throw a few beer cans and then turn and run. One is caught, and selectively beaten on elbows and knees and then thrown into the chariot. There is a bang and then the distinctive Parisian peppery perfume of gas. The street emptied, a centurion orders his men back to the chariot, they return and salute.

Caesar Augustus.

I go back to sleep.

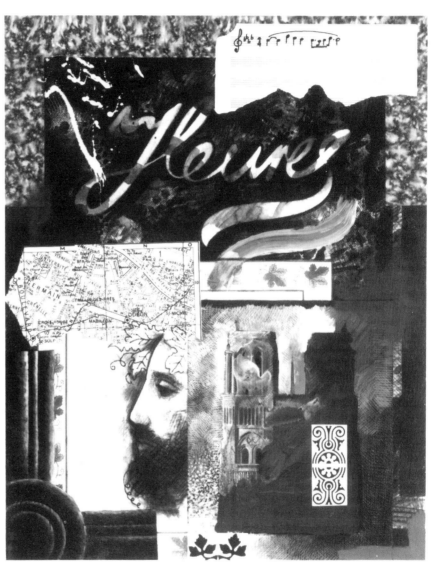

PLATE XLV

Sunday, 15 August

To lunch with Julian More, composer of stage musicals and author of travel books. He lives in the South near Marseilles, but keeps a flat in Paris off the rue Daguerre.

The delightful rue Daguerre is a traditional market with baskets of flowers suspended across the street. It is named, in the appreciative way the French have, after the early developer of photography.

We eat a grilled salmon, and he tells of the Mafia's interesting work on the Mediterranean coast, and of the courage of Graham Greene.

Sheila, his twinkling wife, showed me some fine pencil drawings she has by Alphonse Mucha, known forever for his *Job* poster.

Julian, as befits the composer of the musical *Irma la Douce*, laments the decline in costume design of the hookers on the rue St-Denis, fondly recalling having once seen amongst the usual lace corsets and suspenders, a girl almost bare wearing the head of a bear.

I once walked along St-Denis on Christmas Day, naturally on my way to somewhere else, and was surprised to see *les poules* trading as usual, although one was wearing a Santa Claus red and white fur-trimmed coat over her working costume. I did not see the scarlet pimp.

The street, in the garment district, has oddly appropriate juxtapositions of prostitutes and fashion shop signs, 'Splax', 'Splish', 'Miss Z', 'Spaglex', which suggest devious practices for sale.

What would the martyr St Denis himself have thought, his severed head under his arm, blinking at the fleshy girls as he made his long trek to the site of his basilica? The rue St-Denis, an ancient Roman way, once had fountains of milk and wine, is now occasionally tidied up by the police lobbing a tear-gas canister along it, and like naughty children called in from playing too late at night, hookers, clients and pimps go home.

Julian said he likes to swim. He has a pool in the South, which needs care and combing like a furry pet. I told him of the surrealistic sight of the Piscine Deligny, a swimming pool which for a long time had stood happily on pillars in the river Seine, and collapsed earlier this year. Water into water.

Why is there not a statue to General Kryser, who saved Paris by refusing to destroy it, as Hitler demanded, during the last lost days?

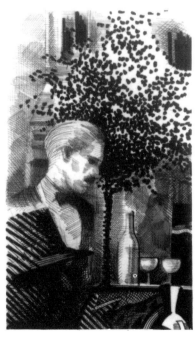

PLATE XLVI

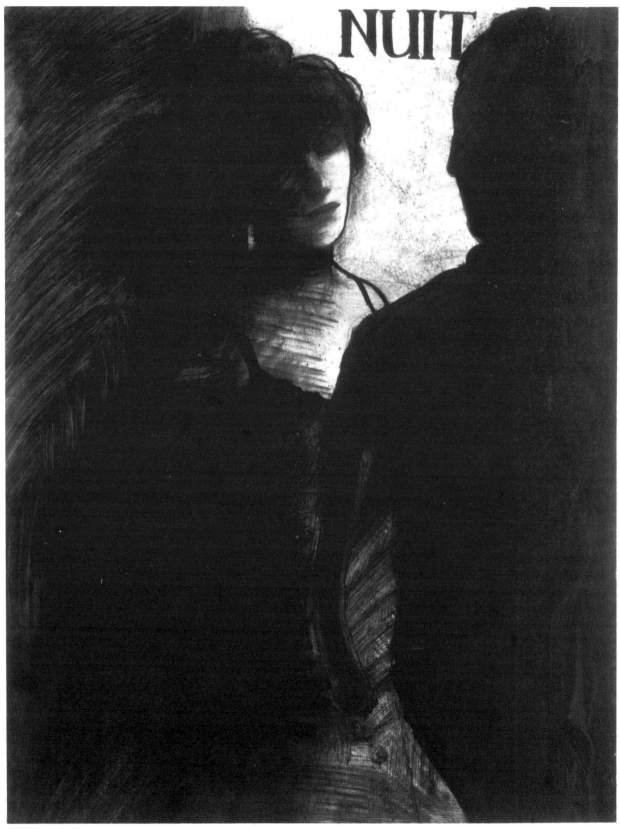

PLATE XLVII

The late afternoon Montparnasse streets had balconies fluffy with geraniums like Libération bunting. I walked past the Hotel de la Paix. Only a country intimate with war would have as many hotels and cafés named thus.

In the Buci market two women busked, grinding an organ fed with folding cardboard Braille-coded music. They sang the street songs of an earlier Paris. They were dressed like nineteenth-century street urchins. M. Daguerre would have recognized them, the sepia dead reincarnated, and the songs that they delivered, arms akimbo. M. Daguerre would have been proud also of the encircling tourists, each equipped with a still or video camera, who filmed not just the singers, but inevitably, each other. An odd infinity of cameras taking pictures of cameras taking pictures,

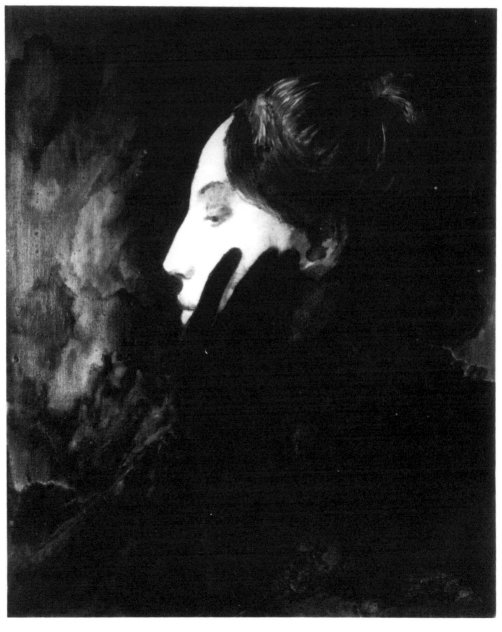

PLATE XLVIII

as if the buskers stood between two mirrors and saw their images reflect and reduce to zero.

I bought a baguette and went home in the last sunrays, to paint and to eat a tin of cassoulet improved with garlic. Why is even tinned French food better than that of English restaurants? Because of the small farms.

PLATE XLIX

Monday, 16 August

At seven each morning the dustbins are wheeled from the courtyard out to the street, for emptying in the lorry.

There are sad pleas as Monsieur Concierge tries in turn to reason with, to gain pity from, to bring to her senses, to whine, wheedle, threaten and randomly but fruitlessly explore all routes to a cold heart.

Last night there had been much running around by firemen and police, to no obvious purpose. All was revealed today: two Africans had been asked for their papers when met by the police on the Pont-Neuf – one had then mysteriously drowned in the Seine. The police are enthusiastic enforcers of the new immigration laws.

For the most part, immigrants, Negro and Arab, live in squalid tower-block estates encircling pretty central Paris, rather like Red Indians encircling a wagon train. On the whole, Africans have a better time than Algerians – some Jazz Age, Josephine Baker-chic survives, sometimes.

The French, squeezed by and wary of German power, their culture constantly assaulted by America, are neurotic. The young and the immigrants live in a fast world of Hollywood films, TV, language, food, music, clothing and graffiti, which have little to do with French tradition.

The nation continues the sado-masochistic (de Sade being French and Sacher-Masoch German, though they have reversed their roles) gavotte, which has seen wars and alliances for so long. Like an addicted beaten wife, France is always coming back for more, trying to reform and control its strong, bullying neighbour.

There is high unemployment, their politicians have little respect, they have seen the same faces for too long, scandal and corruption are in the air. The French are not happy.

But I was and I wandered around the corner to the Place Fürstemberg where a cellist, under the ornamental lamp, was skilfully working his way through a Brahms concerto. The pink and peach brick buildings, the catalpa trees, the angled sunlight pattering the walls in this magical square, made for a state of grace.

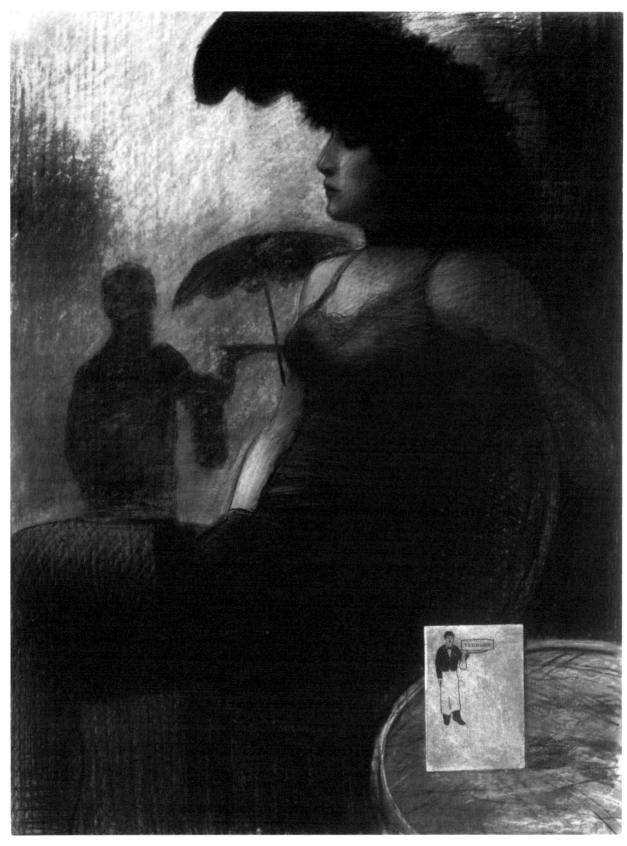

PLATE L

Tuesday, 17 August

On the corner of the rue Christine, a little old lady was giggling while feeding pigeons. She waited until a car came along and then threw down bread crumbs just in front of the wheels, tempting their fate.

Gertrude Stein would not have done that, not to pigeons. She and Alice Toklas spent their last days in the rue Christine, cooking and eating fudge, I suppose.

Monsieur Concierge is standing in the courtyard singing a romantic ballad. It echoes up the walls, tuneless but plangent – perhaps it was their song, it ended with a dying fall.

The telephone picked up the rhythm of his song. Someone is writing a biography of Jeanne Moreau, and as I had drawn her years ago, what did I know? I reminisced about a garden in Provence, flowers, fruit and a lunch in an orchard that could have been from a Colette story. Of a mature Jeanne Moreau, forever for me the heroine of the liberating *Jules et Jim*, in a gingham frock, hair in pigtails, skipping and dancing in circles on the grass in the sunlight.

Jeanne Moreau, Brigitte Bardot, Johnny Halliday, the French never let go of their stars. The covers of *Paris Match* bear continuing witness to their lives' adventures, readers measure their own ageing against them. The British equivalents are of course the Kray twins, Myra Hindley and Ronnie Biggs.

Paris by night, the city of light, to the Cinémathèque at the Palais de Caillot to see a new film. *Métisse*, the film, is *Jules et Jim* revisited except it takes place in a modern Paris that could be New York. It is the story of two men, one Jewish and one black, the lovers of a mulatto girl who is pregnant but does not know who the father is. Its tough urban setting cannot destroy the Gallic charm of the story-telling.

Dinner at Chez André on the rue Marboeuf. A favourite, my kind of food, *cuisine bourgeoise*, served in a restaurant like a railway station waiting-room of the 1930s, by brisk matronly waitresses.

This was followed by drinks at Fouquet's on the Champs Élysées. Once a place of style, it is now a lurid nightmare of ostentation and slovenliness.

Paris by night, the city of light, red and white stripes of car lights run the length of the Champs Élysées. They should have blue street lighting to make a tricolour up to the Arc de Triomphe.

What triumph is this? Buskers wheeze accordions, attempting Arab rhythms for the benefit of the Gulf rich on the terrace of Fouquet's. Fouquet's an onomatopoeia. The Arabs are dressed in Las Vegas show biz, as though their familiar desert was the one in Nevada. The car showrooms ooze an acid-blue light on globular tourists who are attended by pretty gypsy girls simultaneously attempting beggary, seduction and theft. Newspaper kiosks show cheek by jowl magazine covers for lissom health and vile torture. Hamburger scent floats on every breeze, which whispers sleaze. Cinema hoardings wave huge guns over the crowd. Two young lovers pass by arm in arm exuding the distinctive sweet smell of marijuana. Pavements are dug up in front of metallic shops selling black plastic boxes that you watch, or they watch you, or you play with, or they play with you. Junkies blink, winos gibber, homeless beg, as one wades through the desperate trash of this *fin de siècle*.

All cities have a version of this. Not all have the Place de la Concorde at the end of the tunnel, and its compensating fountains, monuments and light.

Wednesday, 18 August

It is said that due to some meteorological quirk, the atmosphere is thinner above Paris and that is why it has such sparkling light.

Below the Pont-Neuf is the triangular island park of the Vert-Galant. One can sit at the point below the flickering trees above the water line, as if in the prow of a boat. Tourist boats and barges sail by and seagulls swoop. In the water a mother duck oversees five ducklings lunching on a floating, sodden baguette. Everyone likes eating in Paris.

Henry Miller said American women came to Paris looking for love, but they would settle for sex. Occasionally, if they cannot get either, they will settle for food. Eating well is the best revenge. Or it may be a preliminary; some of the *bateaux-mouches* are floating restaurants filled with lovers displaying oysters, ejaculating champagne. There is achievement through eating. A familiarity with the *hors* category restaurants is a source of pride to humble toilers, who save their salaries for months to achieve a toqued dinner. Or competing through wine lists, newly discovered bistros, obscure dishes, old friends duel *à la carte*.

In the evening a friend came round to cook us dinner. Jean the cook has lived a long time in Paris; he was the sous chef in a much starred restaurant.

He went to the Buci market and with a precise eye selected vegetables, fish and poultry for the feast. The kitchen became a frenzied gymnasium of boiling saucepans, staccato chopping, grilling, stirring, tasting and seasoning. He twisted and turned and perspired while telling tales of behind the scenes in some celebrated restaurants that would have chilled the bones of George Orwell.

At his present employment, among the brigade in the kitchen, is a master pastry-chef, famous for the delicacy of his work. The decorative swirls of Chantilly cream, his placement of a *fraise du bois*, his marbling of fine icing on a spiralling gateau. He is irreplaceable and consequently well rewarded, by the measure of French catering. His fine fingertips, as he works the choux-pastry, are irredeemably scarred and stained with the oil from his Harley-Davidson. He is, outside the kitchen, a ferocious bechained and brutish Hell's Angel. Fearsome with a knife, and of course there are many to hand, he is stroked with praise as he rattles his chains through his working day.

Nothing was wasted in Jean's performance; ends of vegetables reinforced the stock, one thing would be cooked in the

PLATE LI

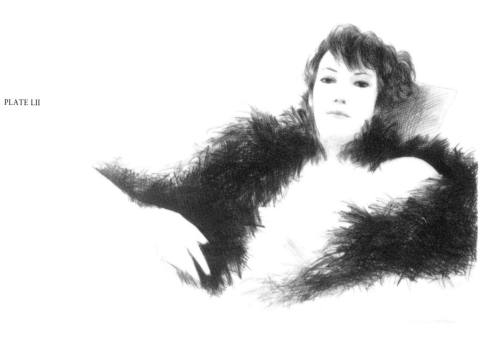

PLATE LII

PLATE LIII

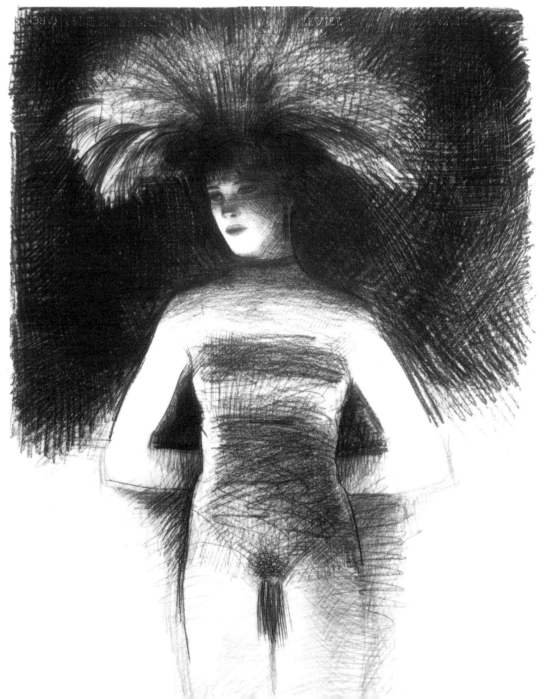

sauce of another, subtly eliding flavour and binding each taste to the next like a scale on a piano.

A salad of *loup de mer*, *haricots verts*, fennel, shallot, tomato, served with a vinaigrette for which all the food writers placed end to end, could not find an adjective.

Quails roasted with a truffled sauce, artichoke hearts, *pommes dauphinoises*.

A few cheeses, a sharp Roquefort, seeping Camembert and ashen chèvre, all washed away with full bodied Burgundy wines.

A sweet cake made with freshly ground almonds, *crème anglaise*, a little *crème fraiche* on the side.

Thursday, 19 August

The temperature is rising – the last few days have been so hot that the buildings have retained the heat through the night. The city is an oven.

Pigeons splash in and drink from the gutters. People drift slowly through the streets, dogs on leads strain towards the shadows.

The heat is having its effect on people I know. Someone telephoned me late last night and begged me not to repeat the story he had told me during the day about an ex-minister's predilection for young boys, as he feared assassination was now the penalty for gossip.

If this were so there would be a massacre to rival that of the Huguenots on St Bartholomew's Eve. One can hardly meet or hear of a French woman without the febrile whisper that 'she was a mistress of Mitterrand's, you know'. No wonder he is gaga.

Sam White was the master some forty years as the Paris correspondent for the *Evening Standard* made him a running tap of the unpublishable. He would do much of his research in the elegant surroundings of the Hôtel Crillon, so assiduously that the owners, when they decided to refurbish, cut off the curved corner of the oak and brass bar, which Sam then proudly displayed in his apartment. For variety he would lunch in the Travellers' Club, often with Jimmy Goldsmith, who was an invaluable source of copy.

Sam was marvellous. He would growl his French like the Australian recidivist he was. The last time I saw him, he took me to dinner in a weirdly (for Sam is a *gourmand*) plain suburban restaurant. 'Why are we here?' 'Wait.' At midnight the doors burst open, and the room was transformed into a Rio nightclub by hordes of shimmering, feathered, Carmen Miranda, Brazilian transvestites, fresh from their work in the nearby Bois de Bologne. He giggled until the small hours.

This evening I was invited to an art exhibition near the Bastille, not far from the new Stalinist opera house, which no one likes, and it is said, was not the winner of the architectural competition, but built by bureaucratic error. Are all the grand new monuments thus?

Down darkened streets, which once housed craftsmen and carpenters, to the rue Charon, past the Café de la Plage, a bar which turn-of-the-century Apache dancers would feel comfort-

able in. Past the building that once housed Clive Unger-Hamilton, who had the odd idea (for an accomplished harpsichordist), to open a fish-and-chip shop. There were two heavy black doors that opened on a candle-flickered path, to a studio at the back of the courtyard. Inside the studio a circle of some hundred chicly dressed Parisians were looking down at a plate-glass box which contained a foetally curled human figure, covered in hennish-brown chicken feathers.

The studio was bare, it had a grey concrete floor and a glass roof. The only source of light hung from a cold iron beam, directly above the glass coffin.

After a time the feathered figure moved, slowly lifted the glass lid, and emerged in silence to stand in the pool of light – it was both bizarre and beautiful. The well-shaped girl was completely and precisely layered with feathers – her hair, face, arms, hands, body, legs and feet.

She pulled them off, one by one, the only sound being a slight tearing noise. They floated in the beam of light, and when she was quite naked she ran off into the shadows to polite applause.

She was Dutch and her name was flip van Loon.

Monsieur Concierge was in the hallway when I returned, unshaven, his T-shirt stained with wine and tears.

Friday, 20 August

Walking is much the best way to move around Paris; one can cross the city in an hour, and have all senses delighted.

Buses are slow, although some still have those open platforms at the back beloved of film directors.

Taxis are unpredictable, sometimes hard to find, sometimes, driven by the deranged – who are sometimes assisted by dogs in the front passenger seat. The dogs turn and stare at you with bared teeth, and, if not actually biting, dribble on you maliciously. It has been worse. A couple of years ago there was a fashion for wiring up the seats so a difficult passenger could be charged twice, once with an electric shock.

Cars, there is nowhere to park cars.

The Métro runs smoothly and swiftly, although you risk being busked or begged at. Much of this problem was recently solved by the police expedient of setting one faction of Yugoslav beggars on to another. Underground ethnic cleansing.

I almost had a closer view of real ethnic cleansing as a result of a party in Paris; parties can be dangerous. I had lunch today with Suzanne Lowry, the *Telegraph*'s Paris correspondent; we had not met for some months as I had been out of Paris. There are two men called Max in Suzanne's life, her son and her editor, Max Hastings. Hastings was at her party in April, and I saw him there. 'Hello, dear boy, how are you? Would you like to go and draw the war in Bosnia? This is our war correspondent, he will look after you.' Later, wisdom prevailed; instead I was sent to Walt DisneyWorld in florida (the French version of Disneyland being of no use to anyone). I was lucky. The war correspondent was subsequently blown up by a mine at the time I would have been in his care. Fortunately, he survived.

The Irish bar played maudlin Irish songs. Suzanne is Irish, sometimes Paris seems full of Irish. One is always meeting or drinking, Guinnesses, perhaps it's all like James Joyce: silence, exile and cunning.

A great Hiroshima-shaped cloud of smoke rose beyond the glass dome of the Grand Palais. Could this be the day the earth caught fire?

I go to my bank in the majestic Place Vendôme, with the column that Courbet once pushed over in the days of the Commune.

It is very amusing to have a bank surrounded by those expensive jewellers and opposite the Ritz Hotel.

Madame Concierge is sweeping out the lodge with a triumphant look.

Five hundred years ago, mere yards from here, was the Tour de Nesle where three princesses lived. They would summon young men to the tower, and if they did not perform as desired they would be thrown to their deaths in the Seine.

PLATE LIV

Saturday, 21 August

Summertime.

Some people I know are going this afternoon to tango by the river. There are, to the astonishment of the passersby on boats, some thirty people dressed appropriately, dancing in one of the amphitheatres on the bank opposite the Île St-Louis. There is a wind-up gramophone, and much brilliantined hair, swirling, flouncing Spanish dresses, intertwining passionate gestures, and stamping stabbing feet. They are perfecting some of the movements of a long-ago Buenos Aires brothel.

I shall not go, perhaps I'll go instead to the Delacroix studio in the Place Fürstemberg and see the delicate Moroccan sketchbooks that are such a contrast to his wild-eyed animal paintings, which are probably self-portraits.

Or I might go to the studio of the symbolist painter, Gustav Moreau, in the rue de la Rochefoucauld, with its deliciously sinuous spiral staircase and lapidary paintings.

I could go to the roof of Samaritaine, and have one of the finest views, because it is at the perfect height, of Paris.

Or I might stroll up the winding, cobbled street market of the rue Mouffetard, and pleasure myself with some unknown cheese or pâté and hope to see the gypsy ritual, where a goat climbs a stepladder to the beat of a drum, a llama stands mindlessly chewing, and a girl twirls with a tambourine. It is all very medieval and seems to mean something, but I do not know what.

Or I could go to the Musée Grévin on the Boulevard Montmartre. A wax museum, within which is a magic chamber, wherein one enters a sealed room and consequently the imagination of the nineteeth century. There one is astonished by a sequence of animated wax figures, moving lights, and exotic flowers blooming and disappearing. Invitations to voyages, to far-off colonial lands and to seductions by dusky odalisques, Negress slaves, languid beauties from the Orient, Indian princesses, and luscious grass-skirted dancers from the South Seas.

There is the perfume of opium here, dark, rich, languorous impossibilities. All the temptations of a colonial empire as described by Pierre Loti.

There is not much of this empire now, but I recall how, in Tahiti three years ago on Bastille Day, at the Governor's mansion the natives, dressed in leaves, danced wildly and lasciviously in front of their uniformed masters and their gloved, hatted and plumed ladies, as if nothing in the world had altered.

PLATE LV

PLATE LVI

PLATE LVII

I will not go to the Musée Grévin today, nor will I go to the Louvre, even though it is inexhaustable. Not even to the rooms of Greco-Roman sculpture, the red marble halls which, like all the best museums, are museums within museums – not even to see those astonishing figures by Praxiteles, or that hermaphrodite, lying on Bernini's carved bed, who was once observed by an English lady of the eighteenth century, to be 'the most happily married couple' she knew.

Sunday, 22 August

The Sundayness of Sunday makes it rain. It stops and I go to the Buci market and buy the *Sunday Times*. In it there is a long obituary for a Persian cat I knew.

There are two tap-dancers busking in between the puddles.

I run into E, a young criminal lawyer. He is much happier now than when I last saw him, immediately after his first case. He had defended a habitual burglar, and the prosecution had demanded three years' imprisonment. After E's speech in

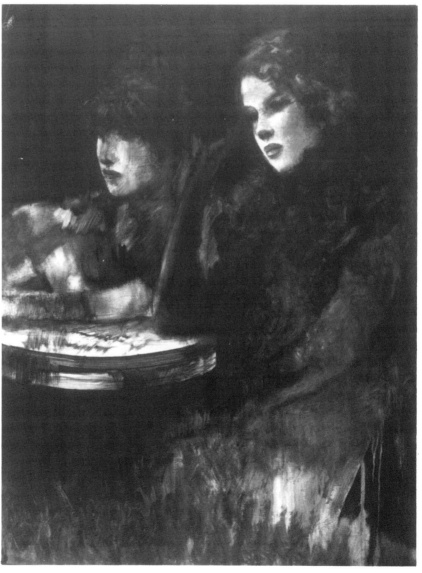

PLATE LVIII

73

mitigation, the prisoner received five years. E had been to an S&M party the night before, and was consequently in good spirits.

There were peasants in broad-brimmed leather hats selling huge sides of smoked ham from Auvergne. Someone is playing a saxophone to six rows of chickens roasting on revolving spits.

I saw Apache, who comes from Madagascar and has long, straight black hair, like a beautiful Red Indian squaw. He used to work in a bar in the rue Mazarine; he tells me he is moving to an old American bar, which is new and therefore very good.

I recognize three men who used to sell Communist party newspapers every week, standing, chatting in their habitual spot.

Three tourists looking puzzled and lost are wearing Mickey Mouse, Donald Duck and Pluto hats.

I wave to the black American sitting at the café, who once told me at great length how he is the unacknowledged nephew of the Queen Mother.

I think of going to the lovely Victorian zoo in the Jardin des Plantes, and decide it is not necessary.

Monday, 23 August

There is an unknown woman cleaning the stairs; Madame Concierge has hired herself a concierge.

There are two Italian restaurants facing each other in the rue Dauphine. They are constantly at war, these Montagues and Capulets. The waiters line up outside and exchange culinary critiques by shouting across the street and with an impressive Latin array of gestures, with finger, thumbs, fists and forearms.

A few people are beginning to return from their holidays, some shops are coming to life, some never will. The recession is leaving its mark everywhere, although with Gallic bravura the

PLATE LIX

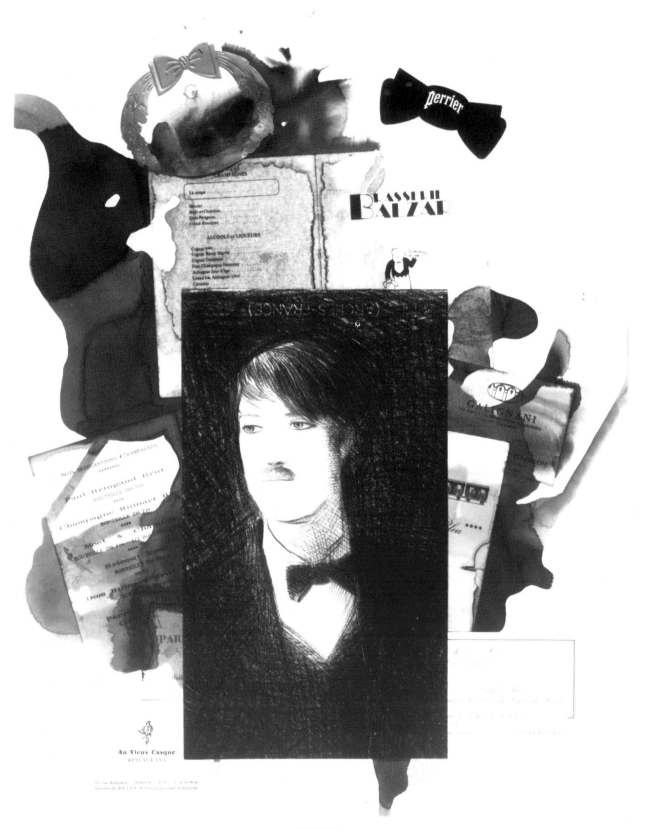

PLATE LX

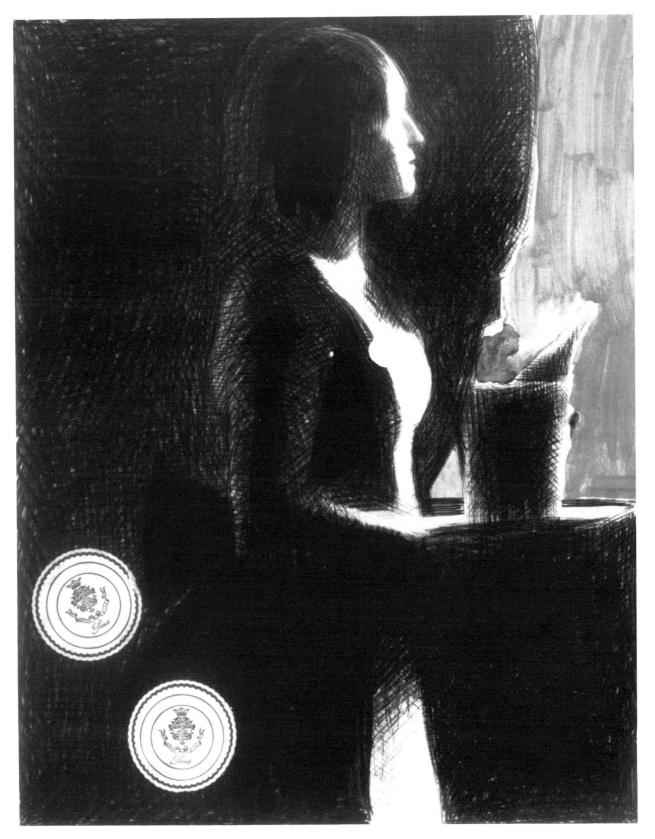

PLATE LXI

signs in the windows read 'Closed for redecoration'. Next to one such shop there is a sign that says 'Come and see the Catacombs'. This is also redundant; this door is no longer used as an entrance to the myriad tunnels filled with skulls and bones, which disconcertingly lie at rest beneath the streets.

Two new restaurants are about to open. One is a rather grand 'cuisine traditionnelle', the other, just across the street, is fast 'Tex-Mex'. Another battle for the hearts, minds and stomachs of contemporary Parisians.

One must choose with care when eating in August. I went to a restaurant I know quite well, but I was unable to recognize any of the staff and the usual chef was on holiday. The food was awful. My companion was not allowed the traditional Gruyère cheese with her *soupe de poisson*, on the grounds that it stuck to the bowl, and made washing up difficult. This seems to be an argument for having restaurants that supply only their ambience and nothing at all to eat.

I returned home darkly through the passageway of the Commerce St-André, where Dr Guillotine invented his machine, and thought how useful it was.

Tuesday, 24 August

'Hypocrite reader, you are like me, my brother.'

Les Fleurs du mal, Baudelaire's great work of poetry, was published in 1857. Certain poems were condemned as an offence against public morals. In August of that year he was fined 300 francs. In one of the most celebrated of the poems 'L'Invitation au voyage', are the lines: 'Là, tout n'est qu'ordre et beauté/Luxe, calme et volupté.'

In 1905 Henri Matisse exhibited the paintings that scandalized his critics and so earned him the appellation 'Fauve'. One of the paintings was entitled 'Luxe, calme et volupté': it shows seven naked women on a beach.

Today a friend, who has been staying on his way back to London from the South of France, in consideration for my need to work, has been out exploring. While doing this he discovered a club on the rue St André des Arts called Chuchotte, which has the subtitle 'Luxe, calme et volupté'.

Naughty Paris, the traditional place of many an Englishman's higher education.

Over supper, my friend related his adventures, which began inauspiciously: he paid 300 francs entrance free to a Moroccan with an earring, and was invited to voyage into the small theatre, where he promptly fell down the steps on to the stage and on to a plump naked pretty blonde.

'Have you hurt yourself? It will be all right, Monsieur. Our next routine', she whispered, 'is doctors and nurses.' He found his way to one of the twenty comfortable seats, four of which were occupied by gentlemen he described as 'distinguished'. There were also a middle-aged man and woman seated together, also 'distinguished'.

The show must go on.

There are four girls, 'very attractive', one blond-haired and white, one dark-haired and white, one Negress and one mulatta.

There is the stage 'where all is' not quite 'loveliness and harmony, enchantment, pleasure and serenity' – it has raw brick walls hanging with chains.

'Gleaming furniture, polished by the years, wood, rich and lambent, decorate our room.' There is a Gothic wooden chair on which a girl sits to remove slowly and lazily her lacy clothing.

Overleaf: PLATE LXII

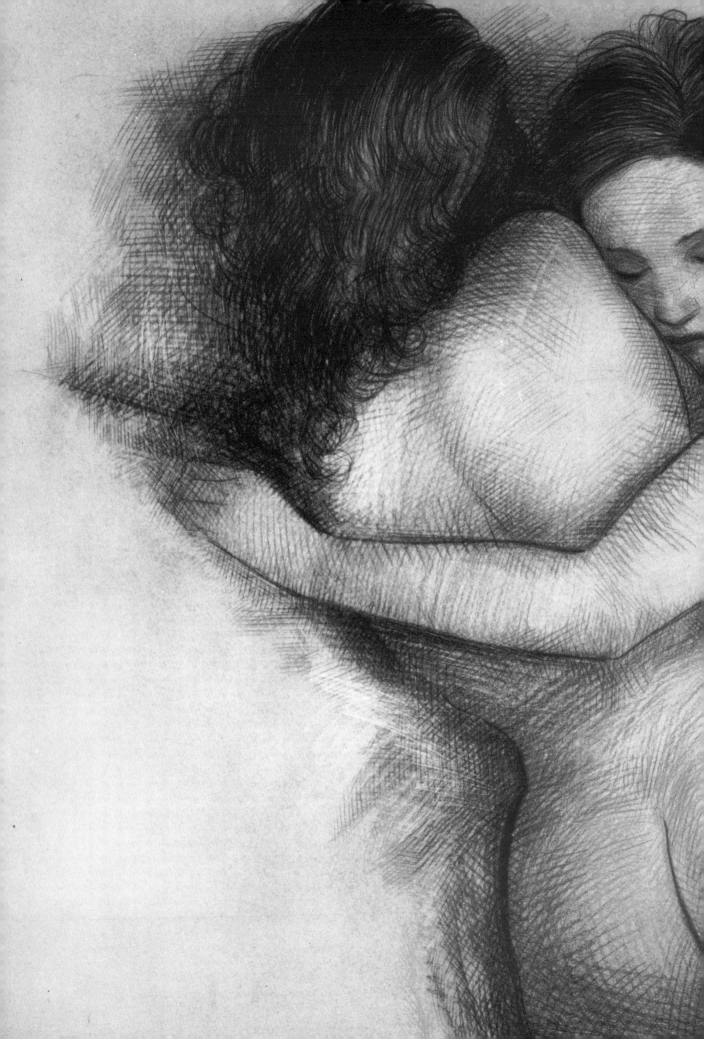

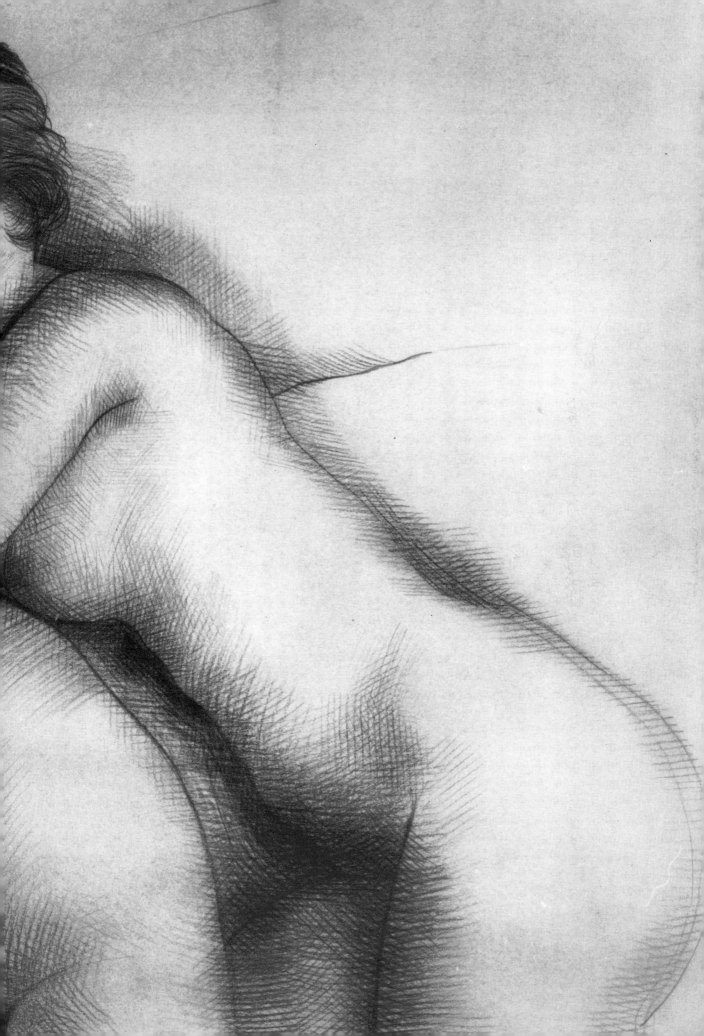

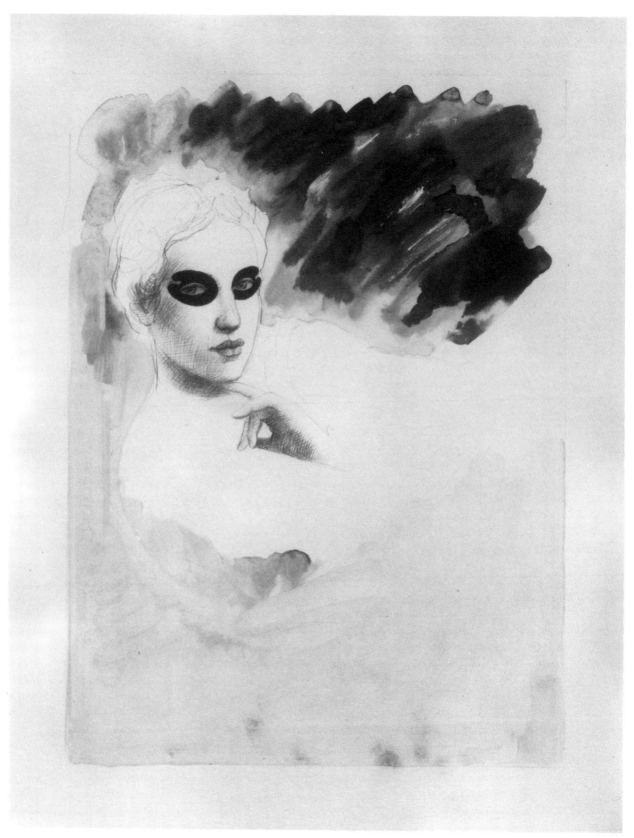

PLATE LXIII

PLATE LXIV

'Rich ceilings adorned', are the same raw brick, but 'mirrors profound' make up the side walls of the stage. 'All of them would speak/To our souls, oblique,/The language sweet they understand the best.'

The audience understands; there are a series of moving tableaux.

To the music of Mozart sonatas, or heavy rock where appropriate, the girls in various combinations perform their routines. As well as doctors and nurses and several untraditional stripteases, there is, he tells me, an interesting version of Red Riding Hood, with one of the girls dressed as a wolf. There are the warm bath-time attentions paid by a lady's maid to her mistress, and the taming of a ravening wild beast in leopard skin, by a lady dressed in a black leather cap and greatcoat, and armed only with a cat o' nine tails.

Fleurs du mal are thoroughly explored and fondled, petals parted, stamens stroked and licked.

It is possible, he said, to go to a private room for an additional fee, and there while separated by a glass wall 'mingle

PLATE LXV

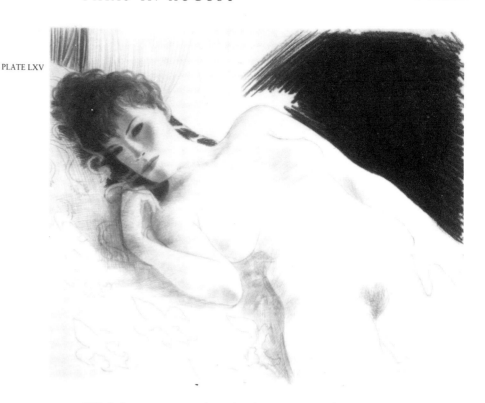

attar/With bergamot and amber's vague perfume', and after have a cup of tea and a slice of sponge cake with the very understanding blonde girl.

My friend toyed with his asparagus at the dinner table and delivered a disquisition on the comparative merits of such establishments in Paris, Amsterdam and Tijuana. To this I could add some knowledge and of the gentler entertainments offered by the Crazy Horse Saloon, and the bathos of the now deceased Folies-Bergères, where I had witnessed sad creatures miming to a recording of tap dancers.

My friend said there was a show on the rue Pigalle that featured boys and girls and many acts of sadism, amusingly called 'Éducation Anglaise'.

This is not to my taste, and I rather wish that the French tourist board would reconstitute Natalie Barney's Sapphic *Temple à l'Amitié*, from the beginning of this century. Where, in the garden of her house in the rue Jacob, 'l'Amazone' Miss Barney used her inheritance over many years to entertain wreathed and tunic-wearing acolytes of Lesbos. The temple was in classical Greek style and the performers and guests in this Arcadia included such nymphs as Mata Hari, Colette and Liane de Pougy. I would not be allowed in anyway.

Now, for the most part, the sex industry in Paris, like so many sources of charm, is rather brutalized and Americanized; perhaps L'Académie Française will proclaim on this problem in the same way that it so strenuously tries to defend the French language. It is an abuse of the tongue.

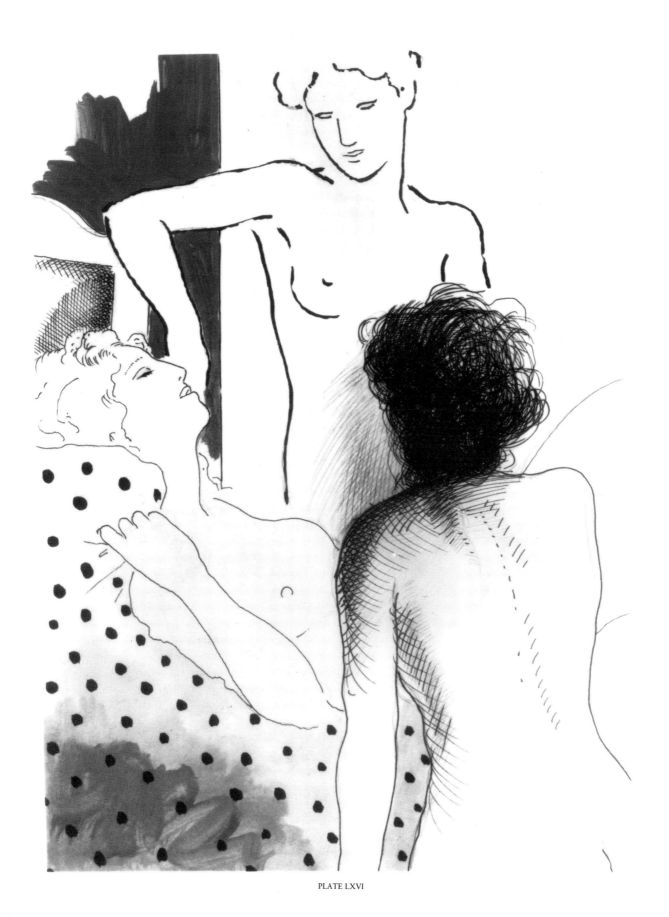

PLATE LXVI

Overleaf: PLATE LXVII

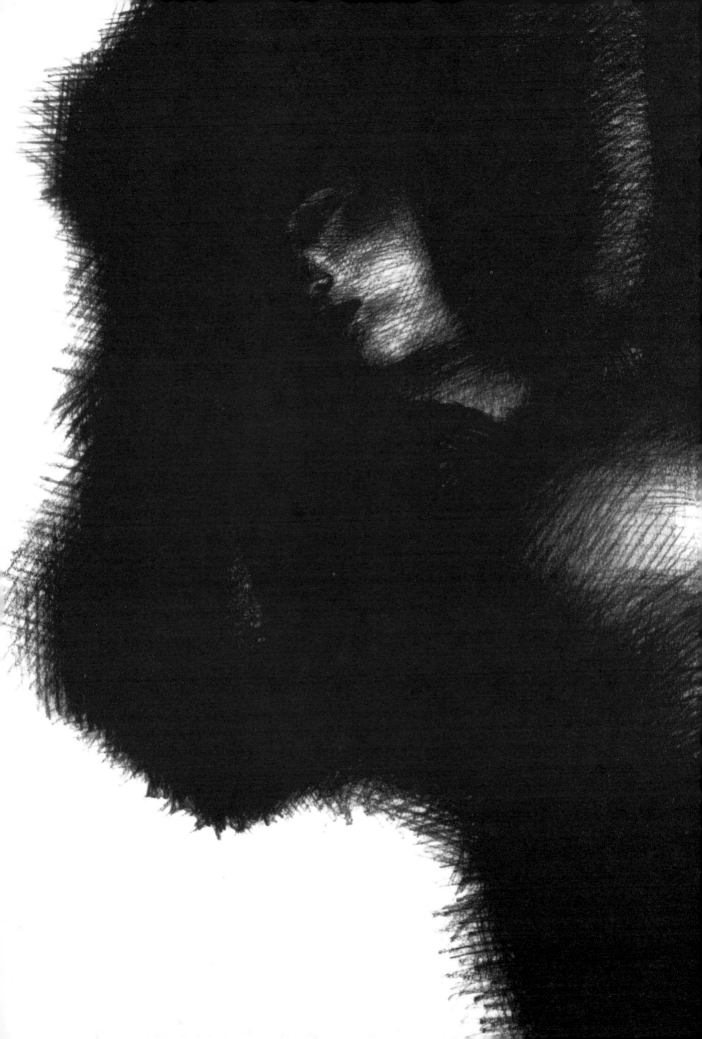

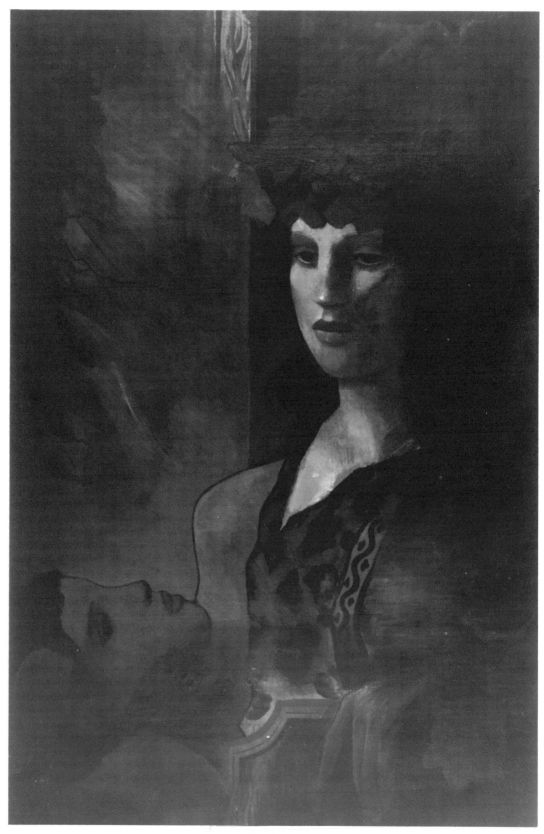

PLATE LXVIII

Wednesday, 25 August

I met some friends who were in Paris for a few days at the Café de Flore. I suggested some exhibitions and museums that I thought might entertain them. I saw them later in the day, weighed down with bags and packages. 'Well, we went to the Musée Brasserie Lipp, and then we went to the Musée Christian Lacroix, and then the Musées Saint Laurent, Chanel, Hermès and Charvet, where I bought him this tie. We then went to that exhibition at Guerlain, do you like this scent? And then to the show at the Didier Lamarthe museum, isn't this a divine handbag? Then because we had walked to so many exhibitions and museums I just had to buy some shoes at the Stephane Kélian museum and

PLATE LXIX

89

PLATE LXX

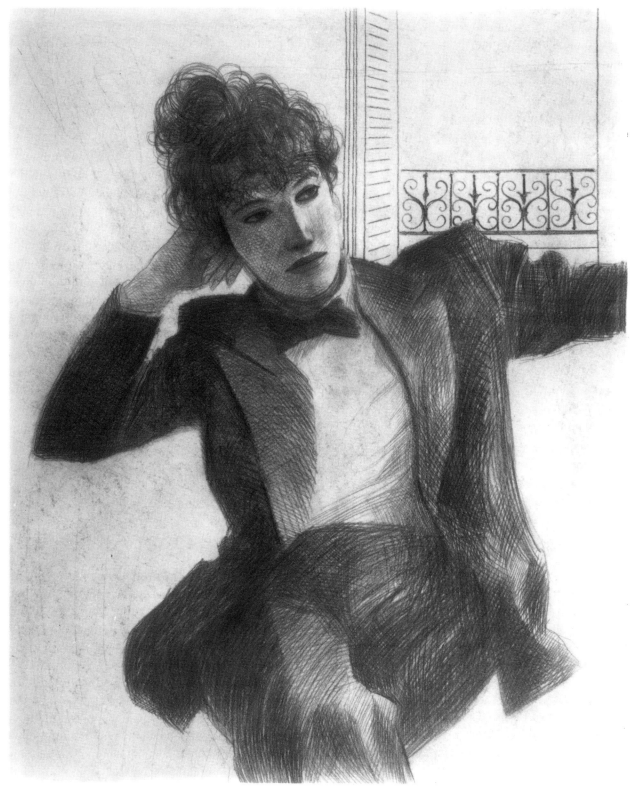

PLATE LXXI

I had to have my hair sorted out at Alexandre de Paris, and then by chance I came across Jean Laporte in the rue des Capucines, and fell in love with these scented gloves, and then just a few handmade chocolates from Debeuve et Gallais, they are museum pieces don't you think?'

Thursday, 26 August

The French use cafés all the time. Even the prosperous live in surprisingly small apartments.

The famous terraces of St Germain, the Flore and the Deux Magots, resemble the terrace of the Carlton at Cannes at this time of year. They are crowded with Eurotrash, polished and self-conscious, who giggle while Rome burns.

From my café the Buci market is a Balthus painting made flesh, all surreal juxtapositions. A man walks by carrying a wire sculpture that could be Giacometti's skeleton. Jean Cocteau and his boyfriend are buying courgettes, and Gertrude Stein waddles by with a long baguette under her arm and figs in her basket.

The composer Virgil Thomson once told me about Gertrude Stein. They were great friends in the 1930s. He had lots of stories, none of which I can remember, because we were in his home in the Chelsea Hotel in New York, and he had just discovered buffalo grass, a curious herb he used to flavour several bottles of vodka.

Paul Bowles, also a composer in Paris in the 1930s, until Gertrude sent him to Tangier where he became a writer, spoke about her in May this year. But this time the problem was *kif* and poor Gertrude became inextricably tangled with giant ants in the Guatemalan jungle. I do recall Bowles telling me this: Christopher Isherwood, who was his friend in the 1930s and subsequently used many of Paul's adventures and his surname for the character of Sally in the Berlin novels, repaid him in the 1960s. Bowles was teaching in California and became very ill, was alone and starving in his apartment until Isherwood searched him out and 'saved my life'.

I ordered another coffee and read an English newspaper. The final testmatch of the summer had been played.

A white masked juggler begins a performance, rotating two, three, four butter-yellow balls up and down, up and down to the pavement, and up on to a table where one knocks over a carafe of water and bounces neatly into a coffee cup, like a setting sun. Amidst the screaming and cursing the juggler stands, abject in his misery and failure.

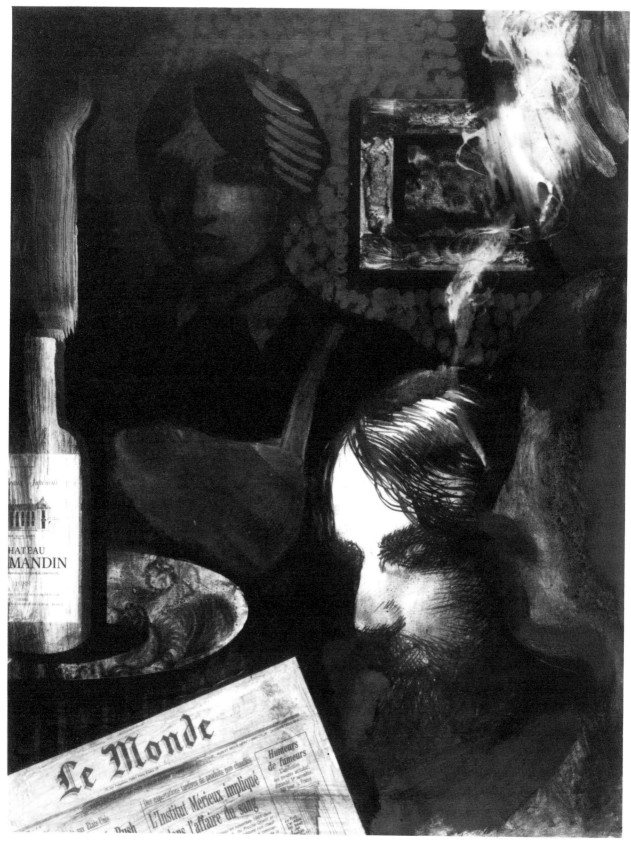

PLATE LXXII

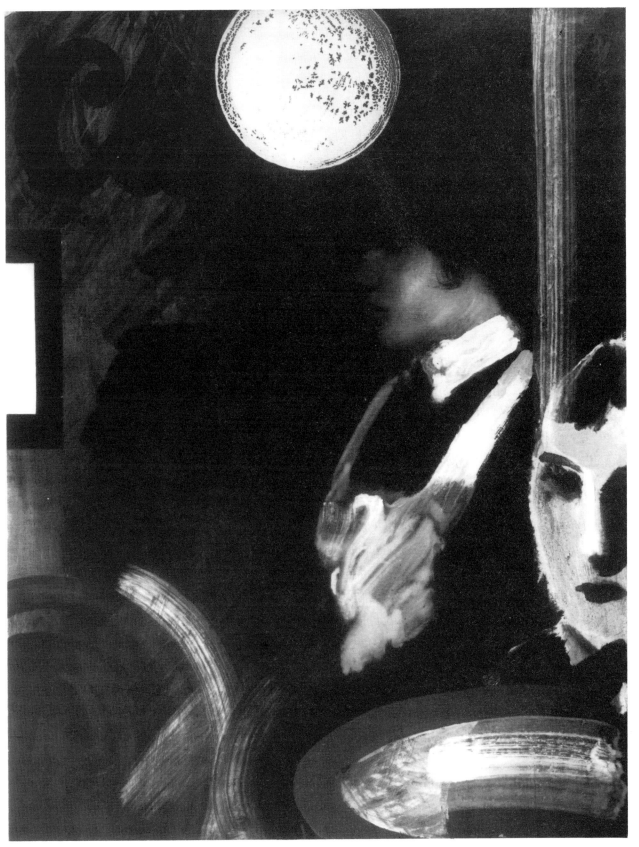

PLATE LXXIII

Friday, 27 August

Shall I give a party? Am I brave enough? The people I know in Paris, both French and others, are so peculiar. It is said that most people live lives of quiet desperation; these people are not quiet.

Will it be like the last time? When my guests found the collection of headdresses and grass skirts and beads that I had brought back from the South Pacific, and frolicked for days? Each time they left, they came back carrying croissants and champagne, and began again. It seemed to last for a week.

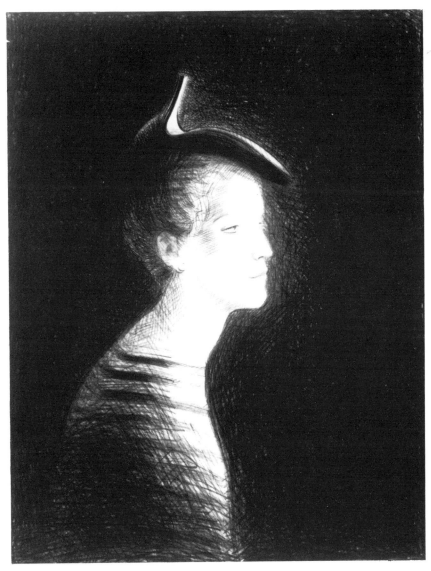

PLATE LXXIV

97

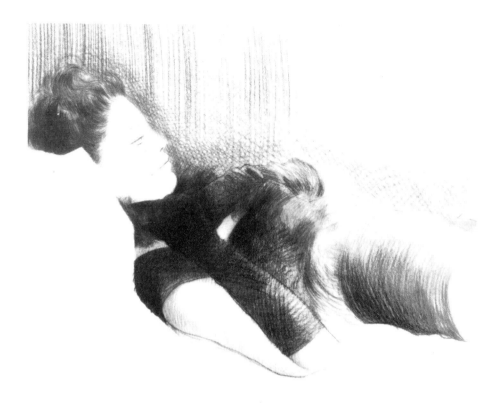

PLATE LXXV

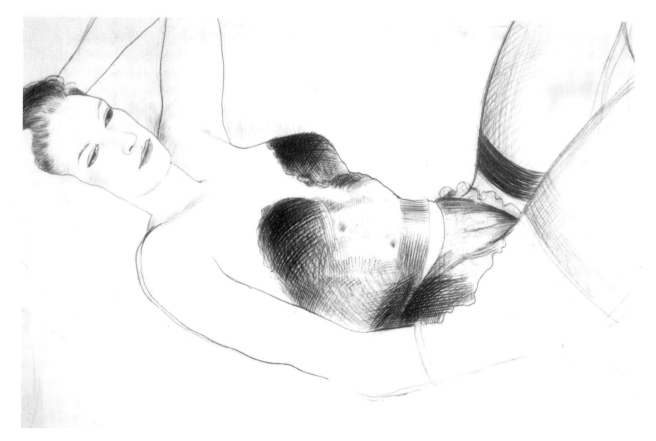

PLATE LXXVI

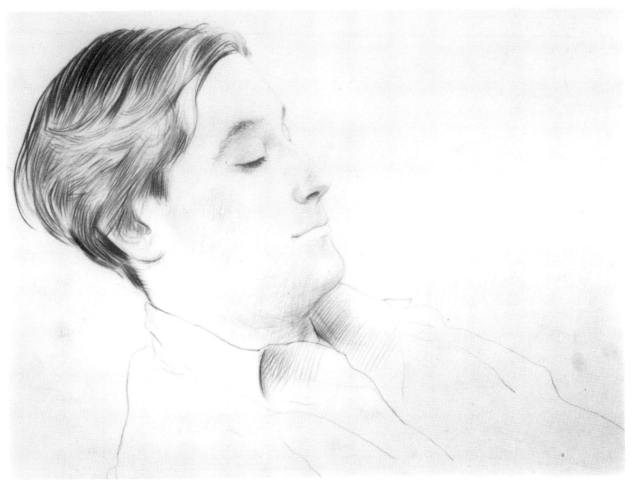

PLATE LXXVII

PLATE LXXVIII

PLATE LXXIX

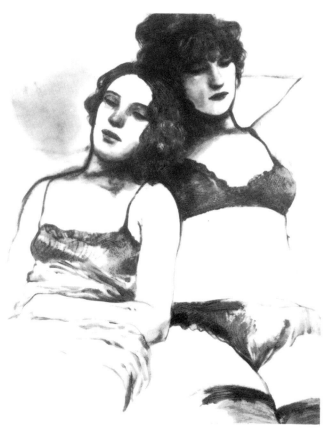

PLATE LXXX

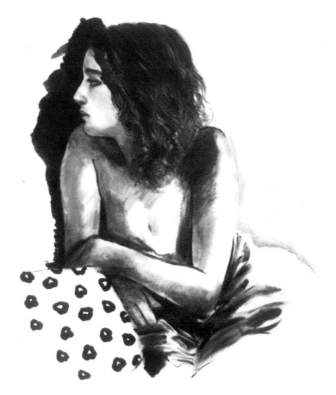

PLATE LXXXI

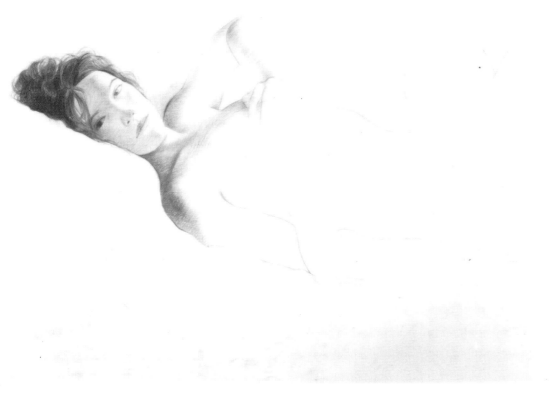

PLATE LXXXII

Or shall I give a lunch party? Do I dare? When I last did that, among the guests were some English girls, all from the most respectable backgrounds, the grandest girls' schools. They found some sculptor's clay and proceeded competitively to mould models of their boyfriends' willies and stick them on their plates. They then danced until dawn.

Who would I invite? Nothing human to me is strange, apart from the people I know.

Shall I invite the Count J. who always seems to have unlimited supplies of caviar, but is so boastful of his sex life that he is now known as the Count who can count? Or those lady art dealers I last saw wrestling on a carpet for possession of a stuffed pink toy elephant?

Or those sweet young girls who spend their time trying to steal each other's boyfriends, and bursting into tears? Perhaps the curious man with impeccable credentials, who spent ten years as a shepherd in Auvergne to heal a broken heart speaking only to sheep. Or that witty and handsome bachelor, so charming that women flock to him all day, but when night falls he flocks to gay bars to try and misspend some youth.

I think I will save it for another day.

Saturday, 28 August

I am taking my thoughts for a walk on the advice of Diderot, the encyclopaedist. Among the many seductive sights in Paris are the covered passageways. These shopping arcades from earlier days were built to enable customers to make more leisurely purchases away from the crowded streets. There are about ten of them now, mostly in various states of decay, which enhances their mysterious beauty. Céline, the author of the wild and influential *Journey to the End of the Night*, spent much of his childhood in the Passage Choiseul, but my thoughts are walked through the Galerie Vero-Dodat, named after two pork butchers who opened this gallery in 1822.

All the little shops are closed for August. It is empty, and footsteps echo as one walks along the chequered marble floor. The wooden shop-fronts are varnished a deep burnt sienna, with brass strips framing the windows that have brass lettering above to name the owners. Where a shop is unoccupied, and there are several, a single brass star fills the title space. The gallery has a pitched glass roof, made obscure by dust and feathers and interrupted by painted ceilings, now so worn it is hard to discern the nymphs and garlands flying there.

The light flows down the corridor from the arched entrances at either end; it reflects dully from the glass and mirrors and the antique forms peering out from the shop windows.

Walking through here produces the strangest sentiments of half-formed thoughts and nightmares, of secret desires, not fully revealed, and of being born. Somehow this Passage, originally built for shopping, is a passage of time.

The sunlight is shocking as you reach the end, you cross roads to go through an alley, called the Passage de Verité, and you enter the garden of the Palais-Royal. There at the entrance is a small plaque in memory of André Malroux: 'Et après?'

I thought I saw the man who thinks he will one day be the King of Georgia, passing through the colonnade. Royal palaces are a natural habitat I presume, even redundant ones like this.

In the centre of the fairy-tale garden, a great fountain plays, like a palm tree made of milk.

A little gallery is open in the arcade, showing an exhibition of photographs from the lives of Colette and her friends. Most of them are of the ever-photogenic Colette, who lived in the Palais-Royal, but there is a picture of Bettina, modelling a Jacques Fath dress of the 1950s. She was at a party not long

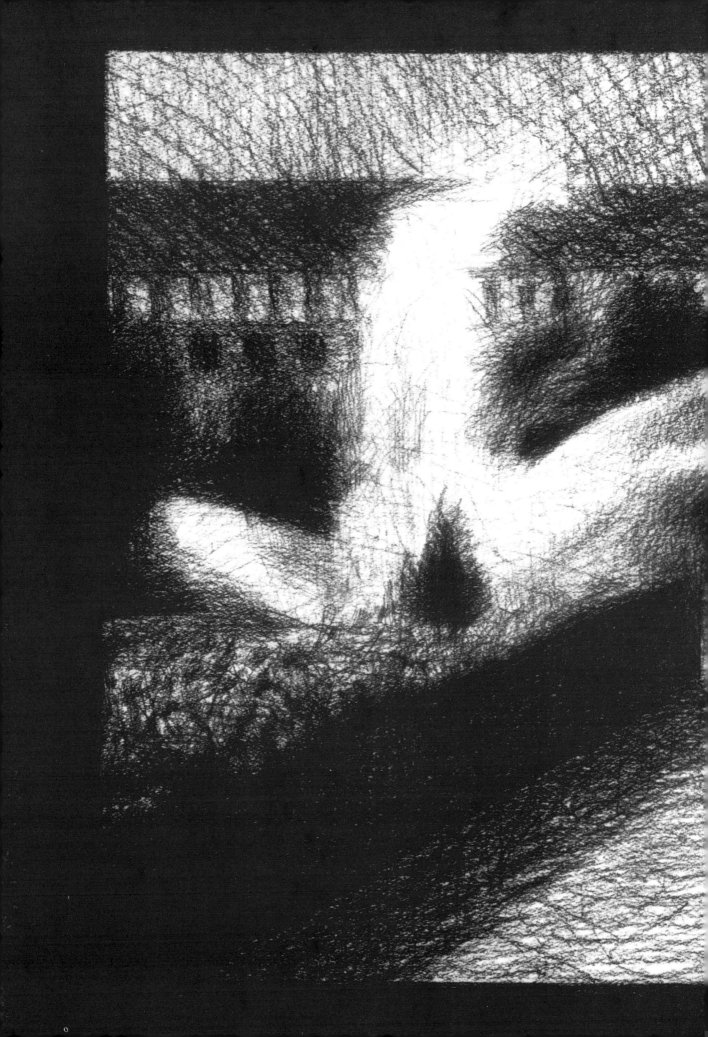

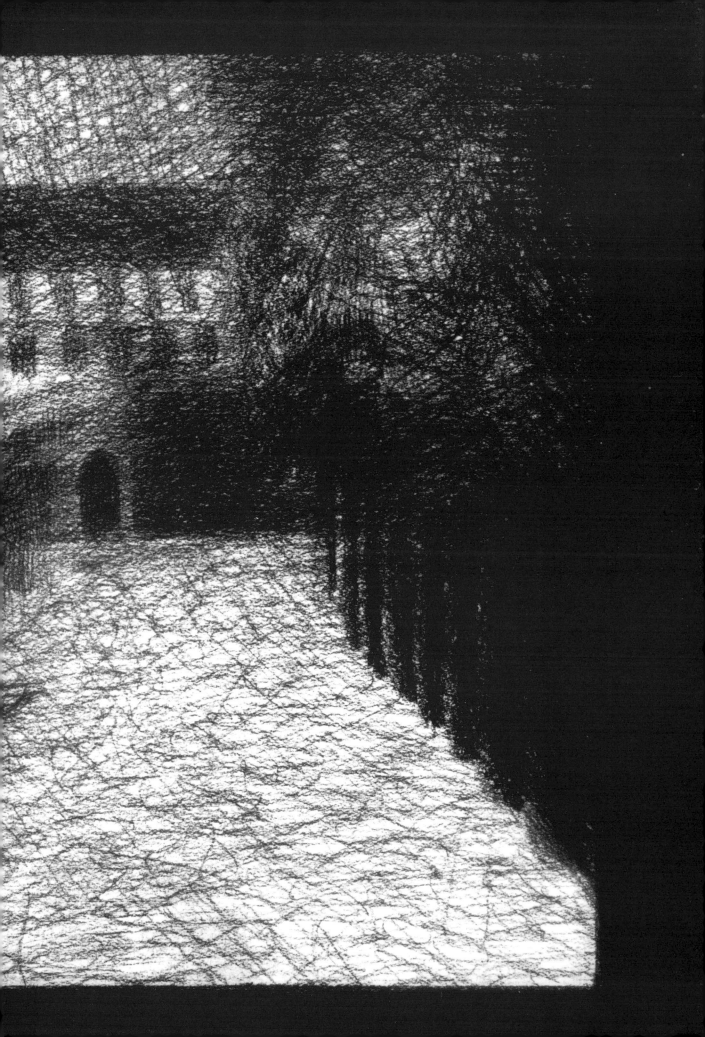

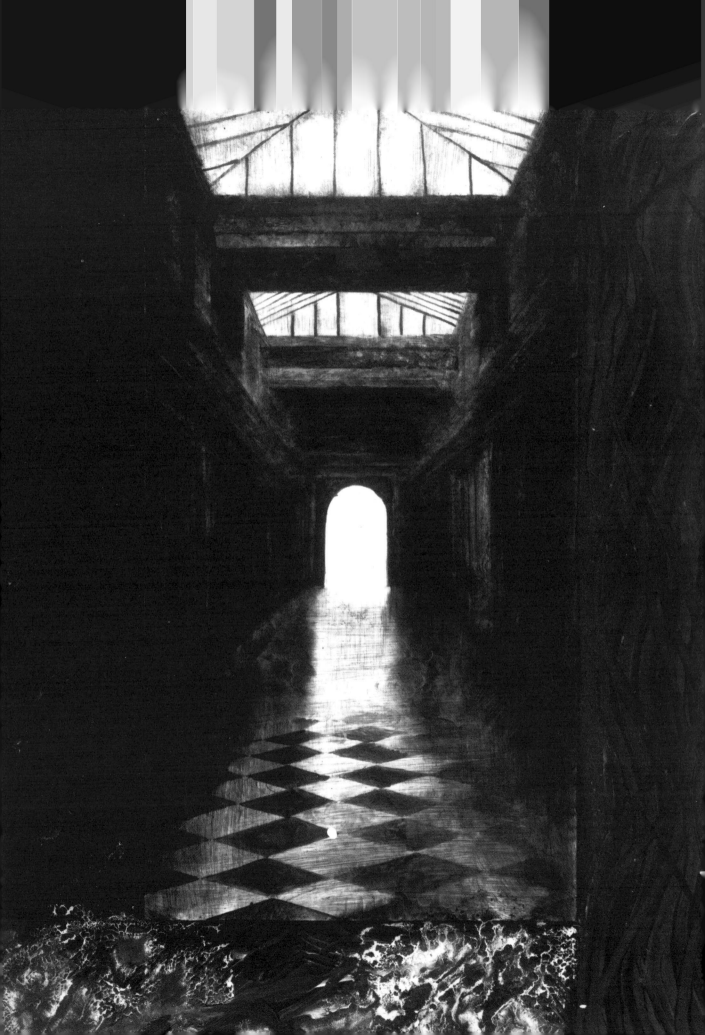

ago, still graceful. There are several of Jean Cocteau, also an inhabitant of this magical quadrangle. Both Cocteau and Colette have societies which work to preserve the flames of their reputations. I was offered leaflets for membership.

There is also an appreciation society for Oscar Wilde in Paris. I was taken to a lunch given by the society in a spectacular house in Versailles. While there I mentioned to a leading French authority on the divine Oscar that the word 'earnest', as in *The Importance of Being Earnest*, was in fact Victorian slang for 'gay'. This intelligence caused such astonishment that he stepped back and fell over one of the many delightfully decorated circular lunch tables. This in turn produced a domino effect, with

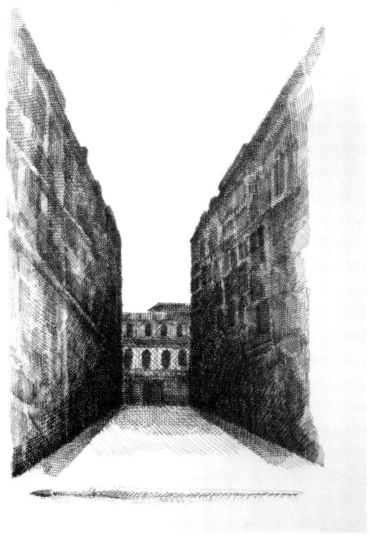

PLATE LXXXV

much crashing of cutlery throughout the room. I was not sure whether to be pleased or sorry that the spirit of Oscar still had such power.

In a shop window close to the gallery was a poster advertising an exhibition in Honfleur, of the works of Paul Helleu. Oscar knew of him. Helleu, an elegant artist, painted his rooms white, shocking for the taste of the time. Oscar followed suit in London and furthermore, the influence of other decadent Frenchmen, Verlaine and the Huysmans of *Against Nature*, helped greatly to fuel Oscar's Icarus life.

I say 'bonjour' to a lady textile designer I know. Her face, because of some printing process that she has invented, is mysteriously impregnated with tiny flakes of gold.

On the rue de Beaujolais, a girl is leaning against a wall. She has blond, short-cropped hair, which gives her the look of a Hitler Youth, circa 1937; she has a leather jacket circa 1955. Underneath this she is wearing a transparent black, finely decorated lace blouse, circa 1910. She has a black corset with suspenders and stockings, circa 1945, and black stiletto boots laced to the knee, circa 1980. She has the indifferent eyes of heroin. This assemblage could be a paradigm for our century; perhaps she will be the next 'Marianne', that totem female that is sculpted to represent the spirit of France. She would succeed Bardot and Deneuve, and be on a plinth, in effigy in all the town squares in the land.

Sunday, 29 August

'Reality is the absence of contradiction,' Louis Aragon said.

Last night in a dream I saw a future. Everyone in it was wearing a uniform black backpack. Plastic and compact, it contained everything to sustain life: a microwave oven, a small refrigerator and a television set. At the press of a button it inflated like a dinghy, completely enclosing its owner in an inflatable cocoon. They were lying dotted on all the streets like black pupae,

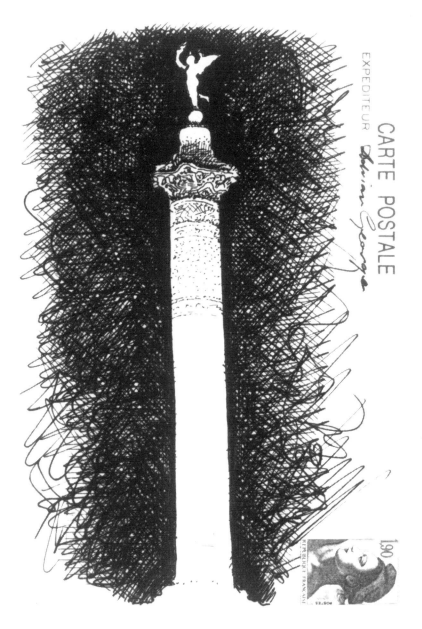

PLATE LXXXVI

expanding and contracting as they breathed. This is the sort of thing that happens when you give up alcohol, or you have seen too many tourists.

In the morning in the market, a painting, half finished, stood on an easel. There was a stool in front, with palette and brushes and a cardboard box with a hand-lettered sign saying, 'Tips, Aider l'Artist'.

Monday, 30 August

While sorting through some magazines, I found this 'poem':

My Paris

Being abroad.

The indifference of Parisians.

The light.

Eating Welsh rarebit at The Select while musing on Kiki cutting up her Schiaparellis. The survival of the Select.

The 4am cabaret at L'Oiseau de Nuit and *Gymnopédies*.

Small dogs in handbags and Petit Diable ice-cream.

The good manners of Bastille's Hell's Angels and balconies.

The appropriate names of clothing shops in the Rue Saint Denis.

The pantomime crocodiles in the Musée des Arts Africains et Océaniens and coffee.

Christmas decorations and glimpses through doorways.

The eyelashes of an Ant.

Sennelier pastels and laughter.

Sunday walks with *bouquinistes* and throwing up in the new Coupole.

The illusions of the waiter at La Palette.

The *politesse* of *clochards* and the Villa Seurat.

The competitive window displays of small bakers' and church bells.

The green chocolate shop with the small cemetery behind where people live.

Père-Lachaise in deep snow and the story that Maillol's model still polishes the sculptures of her body in the Tuileries, but not those of the other models.

The plaque in the Rue de Seine that records Wagner's stay for an hour and a half.

The exquisite melancholy of the Palais Royal and crème anglaise.

The effort to perfect the trivial, and empty streets in August.

Not understanding and consequently romanticising overheard conversations and seeing the river change.

The contents of The Village Voice, lingerie shops and rain.

The salon and the body of the P.

The magic box in the Musée Grévin and the walk from my *appartement* to the bank in the Place Vendôme.

The walk from my *appartement* to Montparnasse.

Adolf Hitler's favourite building.

The view from the roof of Samaritaine and Naples yellow.

The architecture of the Ecole des Beaux Arts and the Count who can count up to 11 times a night.

The parties and legs of Lil of the Louvre and the Place de l'Odeon in sunlight.

The 'Bird' listening to the sound of water in the gutters which looks like blood from the guillotine.

The beach in the Luxembourg Gardens.

Unforseen scandalous scenes.

Fingernails.

Meat and perfume.

The Musée Picasso and Gateau Picasso.

Bumble's *joie*.

P le T's collection and *maquillage* and hair-dressing of elderly women.

Gilded domes and confit de canard.

The absence of the fourth tree in the Rue de Furstemberg and Mme F's limbo dancing at Le Tabou.

Oysters at 3am, tears and lace.

Sitting at café tables and money.

Hermaphrodites and winter trees.

The many hues of grey.

The plangent light of the Cour Vitrine and the disappearances and reappearances of the Eiffel Tower.

The Temple of Amitié and making wishes on point zero.

The memory of Sam White with the Brazilian Transvestites.

Mlle MF's dog's bootees and the shadows on the Rue de Rivoli.

Dawn.

Paint brushes in the Paris American Art store, *soupe de poisson* and the telephone.

The many varieties of *concierge*.

Fromage and gossip and costume parties.

The pursuit of lust and the abandonment of the scheme to build a freeway on stilts above the Seine.

Faux marbre and shoes and drawing paper.

Two mature women fighting over a pink stuffed elephant.

Elegant lesbians and the legacy of Napoleon Bonaparte.

American tourists who look like Ernest Hemingway.

Jean Auguste Dominique Ingres, the Pont Neuf and November.

The prow of the Vert Galant.

The inappropriate clothes of women in the Rue Blondel before lunch and churches made of bones.

The public use of the colour green and stealing ashtrays.

Buying lilies in the Buci Market and *alcools*.

Eating *pavé au Roquefort* in the sleazy brasserie.

Thinking of Baudelaire in the Hôtel Lauzun.

The last refuge for smoking cigarettes and the covered passages at the end of the night.

Stroking tender buttons.

Watching Parisians watching themselves in any surface which reflects.

Hearing the Pachelbel's Canon in the Place des Vosges.

Ox-blood red doors, garlic and charming things.

The relationship between artists and models.

Adrian George is a painter who visits Paris frequently.

PLATE LXXXVII

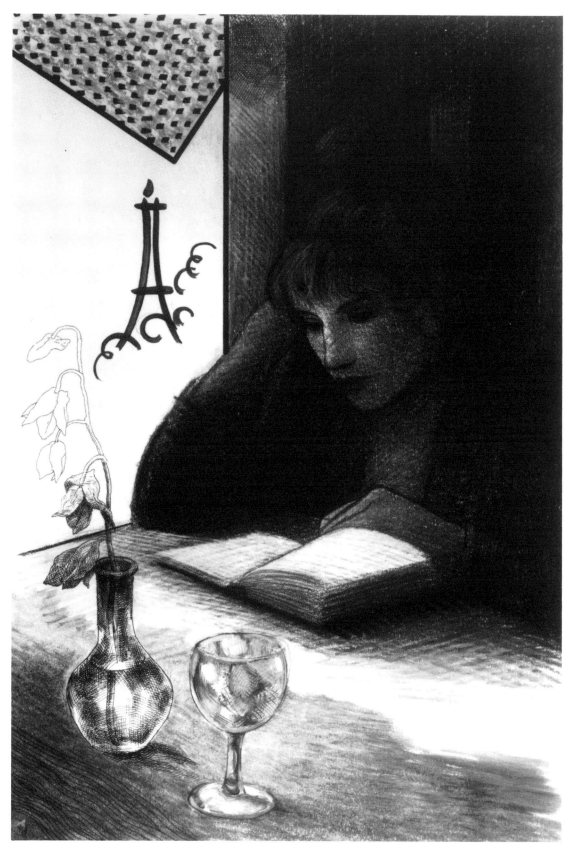

PLATE LXXXVIII

Tuesday, 31 August

I am leaving today, I have to go on a journey, I close my shutters.

The shutters are being opened in other apartment buildings, brown paper is being stripped from shop windows, which are being washed and cleaned. Elaborate displays are made of the wares; Parisians are natural decorators. Fresh food and flowers are arriving from the countryside. All the people with normal lives return - tomorrow is the day that the new year begins, the new season, the new fashions. This time it will be different.

Nothing too bad has happened – August can be a dangerous month. There has been no massacre of the Protestants as in 1572, no recall of the States General, as in 1788, which led to the

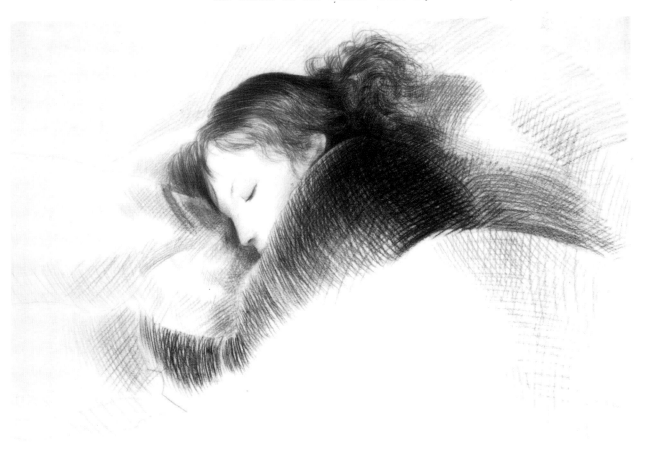

PLATE LXXXIX

113 Overleaf: PLATE XC

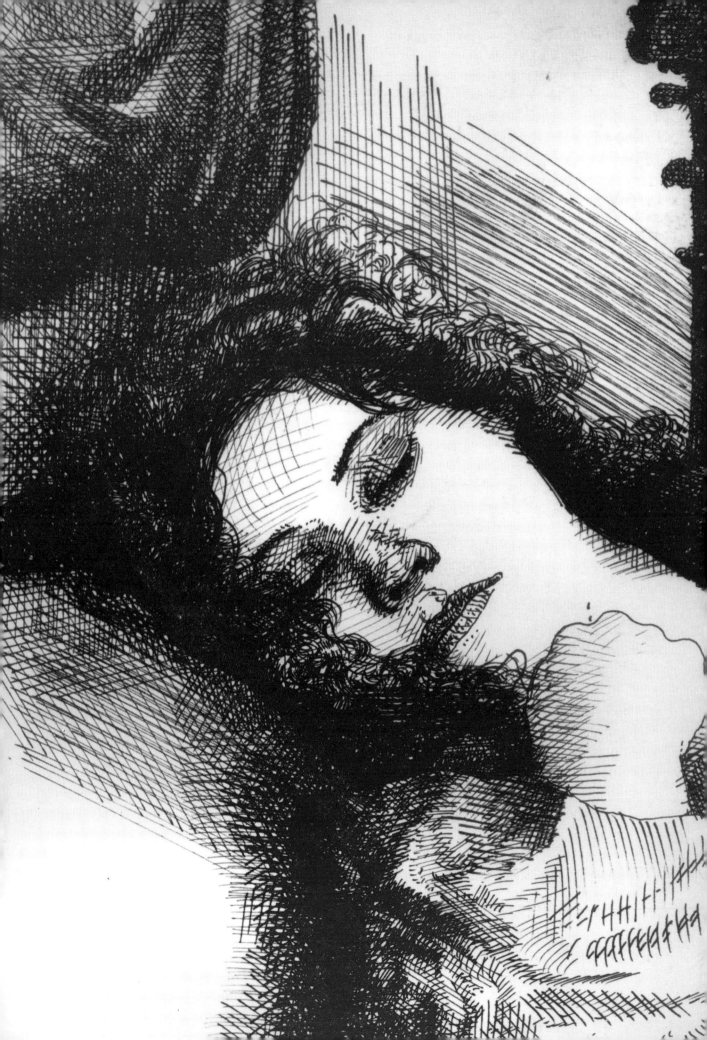

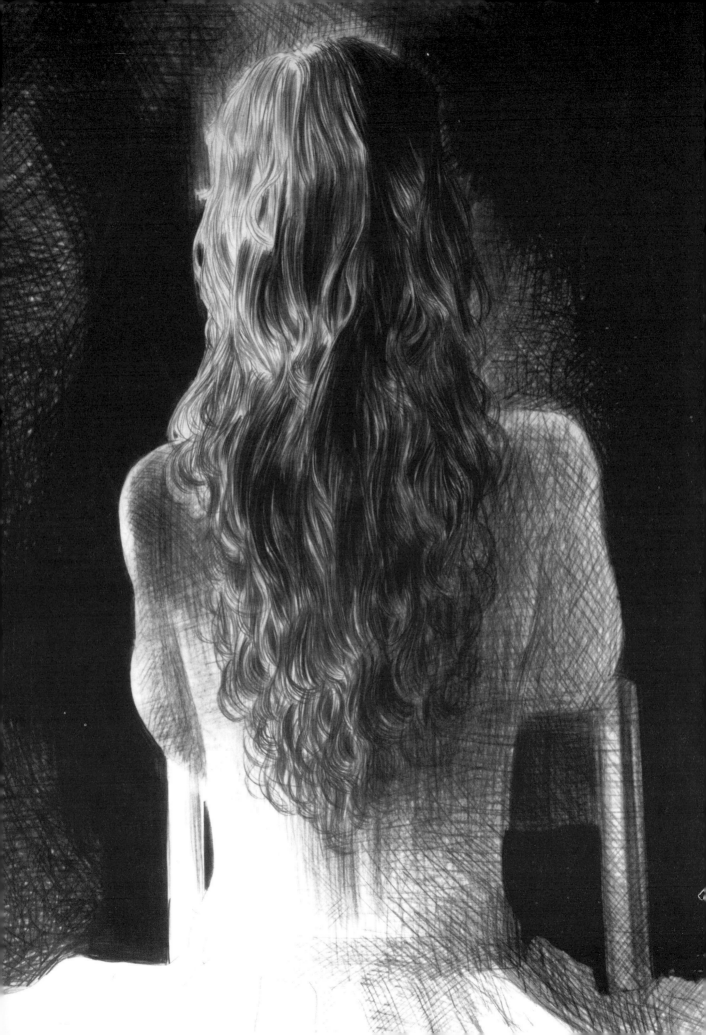

Revolution, no collapse of the army, which left the Germans thirty miles from Paris in 1914, and no resurrection of the Resistance from the *catacombes*, to drive out the Germans, as in 1944.

Bureaucrats return to their *bureaux* on the rue des Augustins; perfumed ladies scent the air on the Quai des Grands-Augustins; children are taught to eat in restaurants in the rue August Compte. Gangsters in Montmartre divide the territory. Checks are being mated on the chess-boards in the Luxembourg, animals are mating in the zoo, lovers are mating in afternoon hotels. Graves are dug in Père-Lachaise, and cafés line up wicker chairs on the pavements of the rue August Caine.

Politicians make copy for journalists for their programmes and papers, feuds are revived, scandals astonish, money is exchanged and earned and stolen and spent. Prices go up, in the square Auguste Renoir.

The ragged army returns from the battlefields, wounded by sunburn, scarred by experience, with tales of victory and defeat at beaches and swimming pools. As though the vacation in August were a ritual of memorial.

As the taxi drove to the airport, past AIDS posters, drab tenements, down sour streets, I noticed a graffiti scrawl: 'This is not the Belle Époque'.

I could see that tower shimmering in the afternoon sun. It marks the spot forever where lovers loved in flowering secret shrubbery. And I feel the sadness, as I always do, because Paris, being feminine, always looks especially beautiful the day you leave her.

Left: PLATE XCI

List of Plates

PLATE	TITLE	MEDIUM	SIZE (CMS)
I	Portrait with flowers	crayon and ink	74 × 43
II	A window in August	oil	75 × 51
III	Head with cubist glass	crayon	60 × 39
IV	Still life with cancan boot	pencil	44 × 32
V	Sleep	oil	46 × 38
VI	Vase and cigarettes	ink, crayon, collage	62 × 49
VII	The kiss	oil, ink	46 × 38
VIII	Marie Mercier	pastel	54 × 39
IX	Matériel pour artistes	oil	46 × 38
X	Clochard	oil	46 × 38
XI	Dog	crayon	53 × 34
XII	Odile Hellier	ink and crayon	51 × 44
XIII	Edmund White	pencil	44 × 39
XIV	Bridges on the Seine	oil, ink, collage	45 × 38
XV	Page from a sketchbook 1	ink, pencil	44 × 32
XVI	Page from a sketchbook 2	ink, pencil	44 × 32
XVII	Page from a sketchbook 3	ink, pencil	44 × 32
XVIII	Page from a sketchbook 4	ink, pencil	44 × 32
XIX	Page from a sketchbook 5	ink, pencil	44 × 32
XX	James Lord	pencil	44 × 32
XXI	La Princesse	pencil	22 × 18
XXII	Table, diner	oil	38 × 46
XXIII	L'escargot	oil	38 × 46
XXIV	Poireaux	oil	38 × 46
XXV	Tabac	oil and collage	62 × 49
XXVI	Croissant	oil	38 × 46
XXVII	Baguette	oil	38 × 46
XXVIII	Bon	oil, collage	62 × 49
XXIX	Painter and model	oil	46 × 38
XXX	Model and painting	ink, acrylic	37 × 29
XXXI	Painted model	ink and gouache	35 × 25
XXXII	L'après-midi	oil	60 × 50
XXXIII	Le soir	oil	65 × 50
XXXIV	Le matin	oil	65 × 50
XXXV	Carnations	crayon	69 × 47
XXXVI	Pictures on a wall	oil	46 × 38
XXXVII	Glass vase	crayon	73 × 54
XXXVIII	Johanna	crayon	76 × 60
XXXIX	Baguette and Beckett	ink	62 × 49
XL	Le Monocle	crayon and ink	50 × 48
XLI	Sphinx by moonlight	crayon	49 × 62
XLII	Marylin M.	crayon	93 × 75
XLIII	Hand and palette	oil	46 × 38
XLIV	La Palette	oil and collage	46 × 38
XLV	Fleurs	oil and collage	62 × 49
XLVI	Waiter and tree	ink	41 × 25
XLVII	La nuit	oil	59 × 45
XLVIII	Head with glove	oil	46 × 38
XLIX	Beauté	oil, collage	62 × 49
L	Rue St-Denis	pastel and collage	65 × 50

PLATE	TITLE	MEDIUM	SIZE (CMS)
LI	Two bottles	crayon	62 × 49
LII	Venus in furs	crayon	50 × 59
LIII	Follies	crayon	78 × 61
LIV	Painted figure	oil	48 × 36
LV	Student with sculpture	pencil	65 × 50
LVI	Tête d'Aphrodite	oil	40 × 30
LVII	Nude with primitive face	oil	46 × 38
LVIII	Café terrace	oil	65 × 50
LIX	Orchids	oil	46 × 38
LX	The waiter	crayon and collage	62 × 49
LXI	The waitress	crayon and collage	62 × 49
LXII	Les deux amies	crayon	52 × 74
LXIII	Palette mask	ink, pencil	37 × 29
LXIV	Models kissing	ink, pencil, acrylic	37 × 29
LXV	Yellow nude	crayon and pastel	50 × 60
LXVI	Three women	ink and acrylic	31 × 23
LXVII	Night drawing	conté	50 × 65
LXVIII	The party	acrylic	76 × 51
LXIX	Gloves	crayon	39 × 31
LXX	Aux Deux Magots	watercolour and collage	55 × 44
LXXI	Transvestite	pencil and pastel	65 × 50
LXXII	Le café 1	oil and collage	65 × 50
LXXIII	La café 2	oil	65 × 50
LXXIV	Hat shoe	crayon	62 × 49
LXXV	Sarah	crayon	50 × 65
LXXVI	Samantha	crayon	49 × 74
LXXVII	Anthony	crayon	29 × 39
LXXVIII	Two models	ink	44 × 62
LXXIX	Sappho	oil	46 × 38
LXXX	Models resting	oil	49 × 39
LXXXI	Charlotte	oil	46 × 38
LXXXII	Nude	crayon	44 × 62
LXXXIII	Fountain in the Palais-Royal	conté	50 × 65
LXXXIV	Galérie Vero-Dodat	oil	75 × 51
LXXXV	Page from a sketch book 6	ink	44 × 32
LXXXVI	Postcard of the Bastille	ink	14 × 10
LXXXVII	A bar in summer	ink	62 × 49
LXXXVIII	Paris in August	oil, pastel	65 × 45
LXXXIX	Sleeping girl	crayon	48 × 63
XC	Sleeping in the studio	ink	23 × 31
XCI	The back	crayon	62 × 49
ENDPAPERS	Black flower 1	crayon	62 × 49
	Black flower 2	crayon	62 × 49
	Black flower 3	crayon	62 × 49
	Black flower 4	crayon	62 × 49

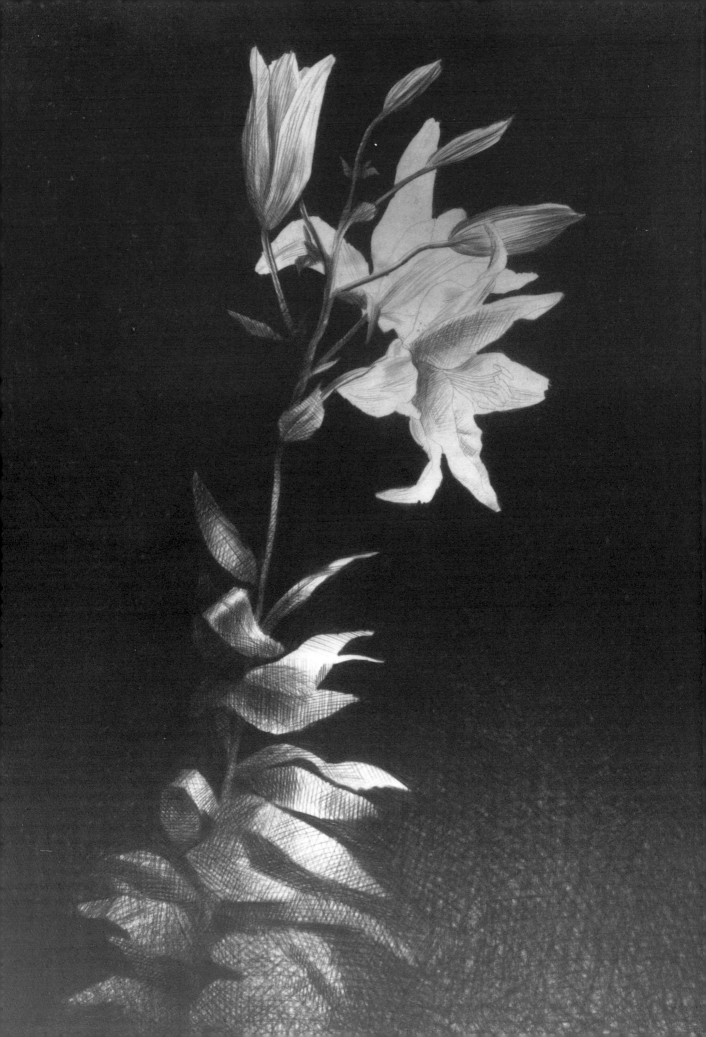